IMAGES
of America

LYNDHURST

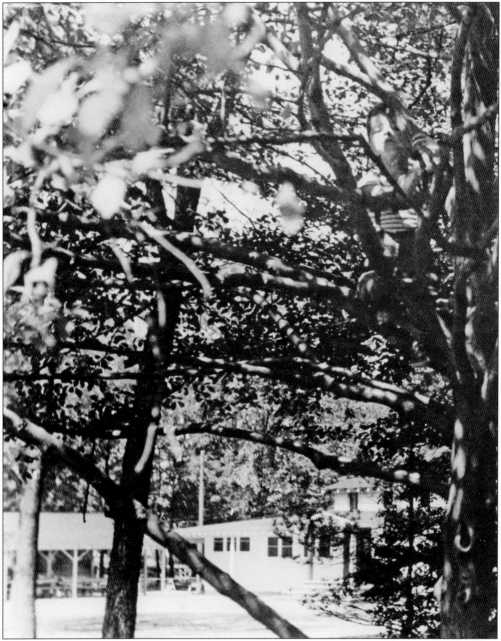

The little boy in the tree says . . . this book is dedicated to my parents, Steve and Theresa Treer. When they moved us here in 1951, they had no idea of the passion I would feel for our Hillcrest neighborhood. A special thanks goes to my wife and kids for suffering through my seemingly endless historical dissertations. I love you all. (Courtesy of the author.)

ON THE COVER: Pictured is the Mayfield Plank Road Tollhouse around 1898. My sincere thanks to Irene Reynolds of Gates Mills, Ohio, for allowing me to copy her family's treasured photographs of the Mayfield Plank Road. (Courtesy of the author.)

IMAGES
of America

LYNDHURST

Thomas S. Treer

ARCADIA
PUBLISHING

Published by Arcadia Publishing
Charleston SC, Chicago IL, Portsmouth NH, San Francisco CA

Printed in the United States of America

Library of Congress Control Number: 2010923952

For all general information contact Arcadia Publishing at:
Telephone 843-853-2070
Fax 843-853-0044
E-mail sales@arcadiapublishing.com
For customer service and orders:
Toll-Free 1-888-313-2665

Visit us on the Internet at www.arcadiapublishing.com

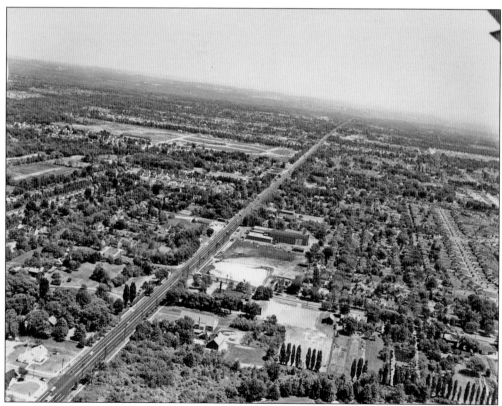

As Lyndhurst changed from village to city in 1950, the home construction boom took off, as this August 13, 1954, photograph demonstrates. Lyndhurst's population swelled from 7,000 to the present 17,500 residents. (Courtesy of the author.)

CONTENTS

ACKNOWLEDGMENTS

All images appear courtesy of the author. This book is a project started over 25 years ago. Folks would loan me their photographs, which I would copy and use to create a historical timeline. I have lost many of those names through the years, and I apologize for that. I have given credit where I am sure. Several collections were formidable. Bruce Young and buddy Jim Spangler supplied the remarkable aerial collection. Irene Reynolds's family of Gates Mills supplied the Mayfield Plank Road photographs. Marie Kregar and daughter Martha loaned me the family Spiegel pictures. Bert Gesing sought me out knowing that I would preserve his unique collection. Cliff and Winnie Noon, fellow photographic historians, had some of my favorite images. Lyndhurst mayor's secretary Clarice White was extremely helpful, as were all city department heads. Lyndhurst service director Rick Glady and his wife, Chris, personally photographed a 2005 aerial view of Lyndhurst Homedays. I know I should thank the Cleveland Public Library, Western Reserve Historical Society, and the South Euclid–Lyndhurst Board of Education, because I am sure some of these images came from them. This has been a deeply emotional experience. Thank you all.

—Thomas S. Treer
Lyndhurst Historian
March 1, 2010

INTRODUCTION

Lyndhurst has its roots in the fascinating story of the Western Reserve. This curious land transaction carries back to 1662, when King Charles II of England conferred on the colony of Connecticut "all the territory of the present state and all the lands west of it to the extent of its breadth, from sea to sea." This astonishing grant was whittled away to a tract bordered on the north by Lake Erie, on the east by Pennsylvania, on the south by the 41st parallel, and the west by a line 120 miles from the western border of Pennsylvania. This was the "Western Reserve," reserved by Connecticut for its own use. Part of this huge parcel was what Gen. Moses Cleaveland came west to survey in 1796. In his employ were 41 surveyors from the Connecticut Land Company. They staged a sit-down strike over better wages and were given 500 acres each, which they called Euclid Township, to develop and live on. Every one of them sold his plot and moved back east. The area presently embraced by Lyndhurst was largely left to Native America and the few white trappers passing through until after the War of 1812. When the Brainard family moved to the area, things began to change.

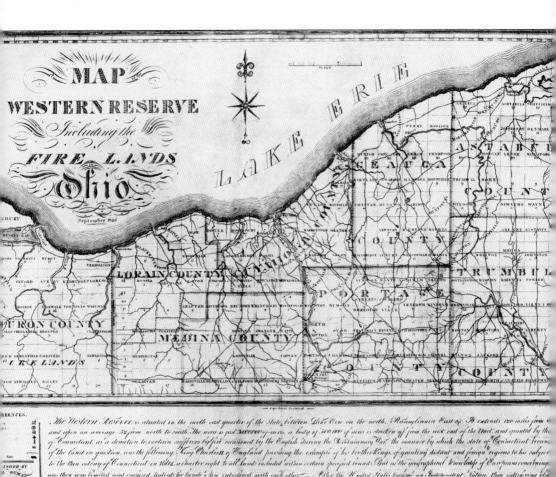

William Sumner of Nelson, in Portage County, published this 1826 map of the Western Reserve of Connecticut. It was made from the actual survey by Seth Pease and Abraham Tappan in 1798. Part of the Western Reserve was called the Firelands. These were tracts of land given to Connecticut citizens who had suffered losses during the Revolutionary War.

One

THE EARLIEST YEARS

As Euclidville changed to Lyndhurst in 1920, the basic design of the neighborhood was already set. This 1951 map shows all the original roads. Spencer Road was the first paved side street in Lyndhurst. Although the first commercial area was at Spencer and Richmond Roads, by 1951, it had long taken root at the crossroads of Mayfield and Richmond Roads.

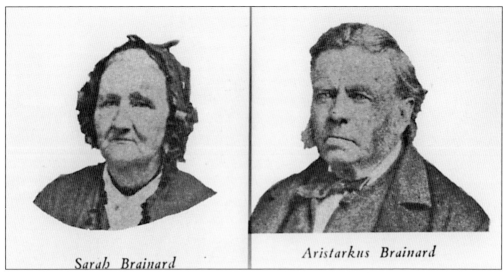

Sarah Brainard Aristarkus Brainard

Aristarkus and Sarah Brainard arrived with son Henry, and records show that Henry's son Bonaparte was born in Mayfield on July 17, 1844. The earliest land transfer to the Brainards that appears in land title records was the purchase of 29 acres from Joseph Selden in 1846.

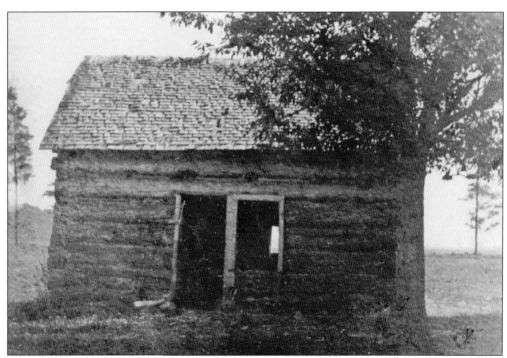

Beryl Brainard, widow of Bonaparte's son Harry, and her son Clifford place the date of Aristarkus's arrival about 1820. They built this log home and lived here until they purchased the property. The frame house, the first in the area, sat where the St. Clare Church convent is now.

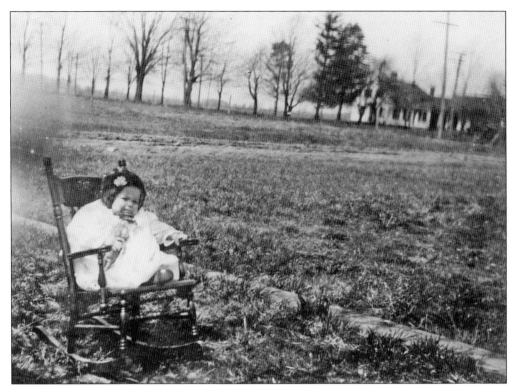

Alice Brainard was photographed at home in 1908. The former tollhouse, moved to 1720 Brainard Road, can be seen in the background.

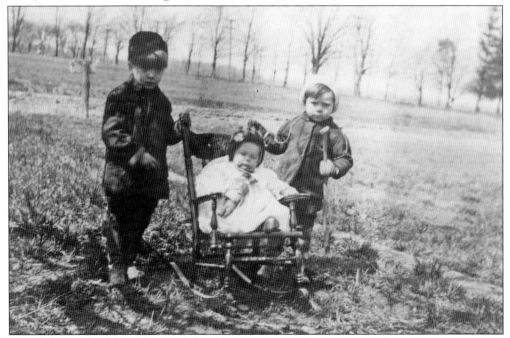

From left to right, Cliff, Alice, and Roy Brainard pose in their front yard at 1711 Brainard Road in 1908.

This was the home of Louis and Seraphina Darrow at 1711 Brainard Road in 1914. Seraphina was Bonaparte's daughter. Cliff Brainard bought the house from Louis Darrow in 1939 and completely remodeled it in 1942. It was their home until 1956.

In 1850, Frederick Wishmeier purchased a piece of property on the west side of Richmond Road near Mayfield Road in 1850. Grandson Henry was still farming there when this March 13, 1949, picture was taken. This was the last working farm in Lyndhurst.

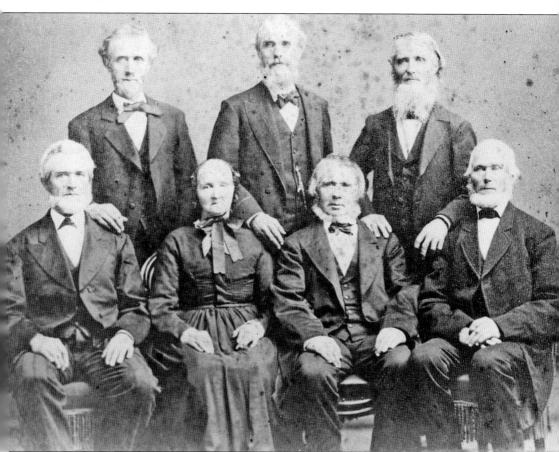

The mid-1800s brought a wave of German immigration to the area. The Melcher family, from left to right, are (first row) Ernest, Elizabeth, Gerhard, and Friedrich; (second row) Heinrich, Joseph, and Adolph. Gerhard arrived in 1845 and bought a tract of land that is now the site of Mayfield Country Club. He later bought more land on the east side of Richmond Road.

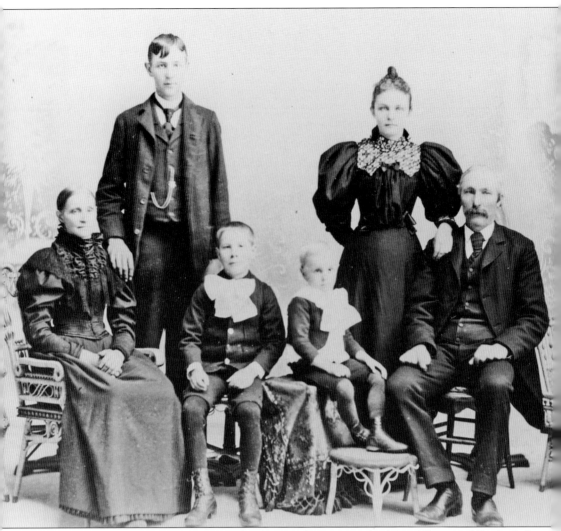

The Detering family is, from left to right, (first row) Anna, Fredrich Jr., Albert, and Fredrich Sr.; (second row) Edward and Emma. They arrived from Hanover, Germany, in 1848. The Detering brothers were among those who voted to incorporate Euclidville into a village in 1917. Their home still stands at 1344 Richmond Road.

Two

THE MAYFIELD PLANK ROAD

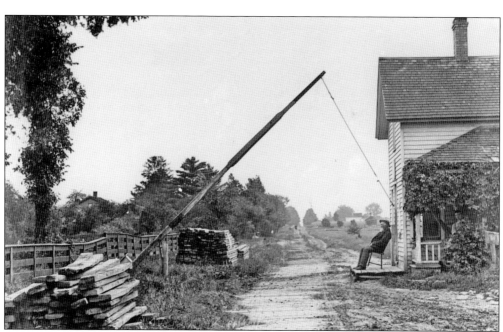

The winter of 1876, with its appalling mud, resulted in the Mayfield Plank Road Company being formed. It would run from the top of Gates Mills Hill to the bottom of Mayfield Road at Murray Hill and connect to Euclid Avenue. Farmers began hauling oak and hickory logs to Gates Mills in the summer of 1877. There they were sawn into planks 8 feet long and 3 inches thick. The road was opened in December 1877. Now the eastern farms of Ashtabula and Geauga Counties had easy access to Cleveland's markets and ports.

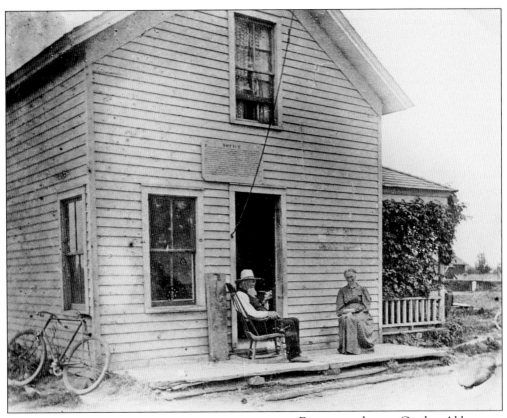

Eastern gatekeeper Gordon Abbey was paid $35 per month plus a place to live rent-free, coal for the office stove, and all the discarded planks he felt like cutting into firewood.

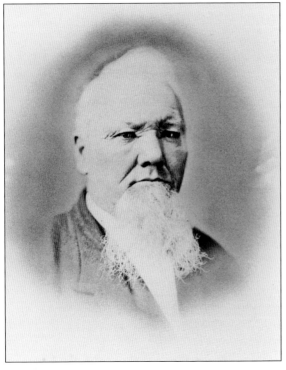

Gordon Abbey, a retired farmer, took over as toll keeper in 1882. Roland Pice, the original toll keeper, died suddenly in that year. Abbey stayed 20 years, until shortly before the road closed.

Mr. Smith, a well-liked man along the road, kept the west tollgate on the northwest corner of Superior and Mayfield Roads. The site was later occupied by Cleveland Heights City Hall.

Belle Gary said, "A man driving a team along a road means little, except perhaps to an artist, who sees a picture on everything. But if he stops, holds a conversation with someone, is called by name, and perhaps tells the purpose of his trip, the whole thing comes to life." Irene Reynolds, great-granddaughter of Gordon Abbey and daughter of Belle Gary, supplied these pictures.

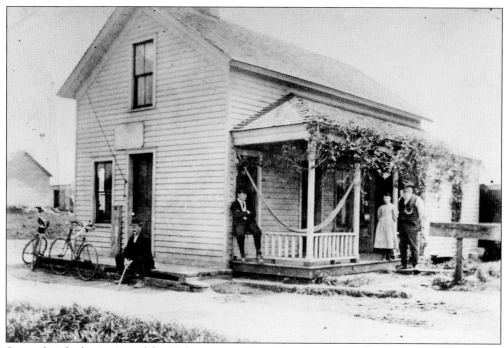

Soon after the beginning of the 20th century, the road was allowed to deteriorate. Gordon Abbey retired, and the electric interurban railway had come. The last planks were torn up in 1907.

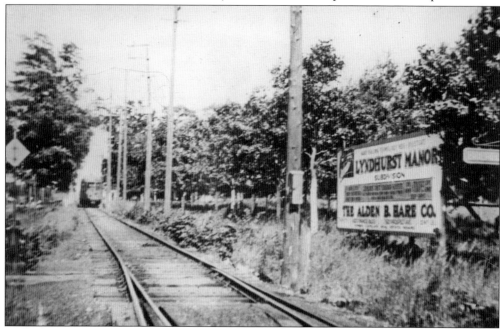

In 1899, the Cleveland and Eastern (C&E) Interurban Railway was built. Freight cars carried passengers and produce to and from Gates Mills, Newbury, Middlefield, and Chardon. Warm cars and the lovely countryside brought weekend tourists "out east." However, the trolley was in a race with the automobile, which won, and the last rails and electric poles were removed in July 1925 in favor of the modern concrete road. The quiet little village was growing.

Three

A VILLAGE GROWS

William M. Emshoff is credited with giving the city of Lyndhurst its name. Born on May 19, 1910, in his parents' home at 5225 Mayfield Road, he attended classes in the little red schoolhouse and graduated from Charles F. Brush High School in 1928. In 1920, a contest was held to rename Euclidville. He saw the name of Lyndhurst, New Jersey, on a map and submitted it. He won the $5 prize and bragging rights for having named his city. His father, Louis Emshoff, was the longtime Lyndhurst service director.

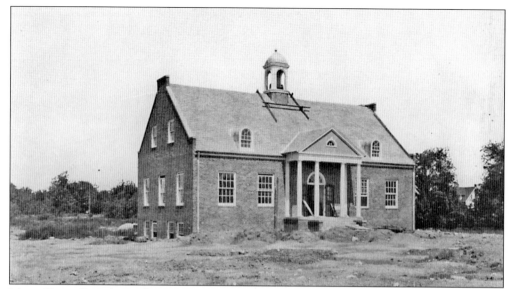

Mayor Harry Guenther's administration brought many improvements to the village of Lyndhurst. Gas mains, sewers, water, and electric service were added. Mayor Guenther had the village hall built in the "Western Reserve style," and it was dedicated on October 2, 1926. Lyndhurst Homedays was started the same year. Held in the park behind village hall, it continues to this day.

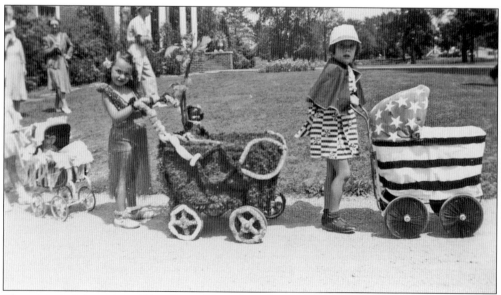

The annual civic outing of Lyndhurst Homedays always included the parade in the park. The park pavilion, also built the same year, housed a ballroom, kitchen, and restrooms and was the village's community center.

20

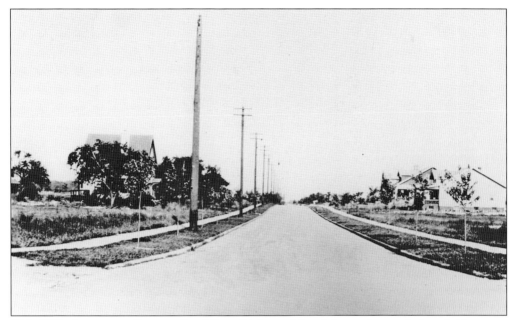

This 1927 view east up Spencer Road from Richmond Road shows the newly paved side street, the first in Lyndhurst. Early businessman George Spencer owned the 52-acre farm that would become Spencer and Edenhurst Roads.

John Spiegel (pictured) and George Spencer conducted meat businesses from their homes on Richmond Road. Other than George Brueggemyer's charcoal business down the road, there was little commerce. Fruit and vegetable farms were common.

The Spiegel family home on Richmond Road still stands, and the third generation of the Spiegel family resides there.

The Richmond Road girls are, from left to right, Marie Spiegel, Rhea Spencer, and Ida Detering. The Spiegel house is in the background. The girls are standing in John Kneale's strawberry field, ready for some picking.

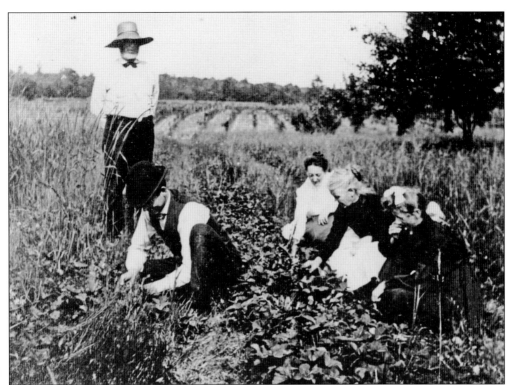

John Kneale (in the white hat) and his family are seen here picking strawberries in their fields at Richmond and Ridgebury Roads in 1924.

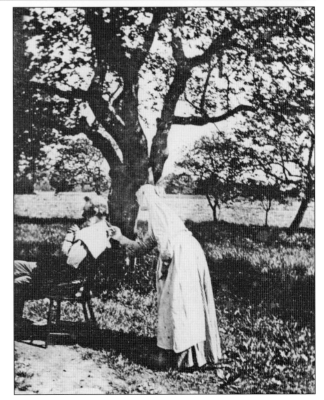

In typical farm fashion, Annie Kneale gives her husband, John, a haircut under the old maple tree. This 1925 photograph shows the farm field behind the house that would become Ridgebury Elementary School.

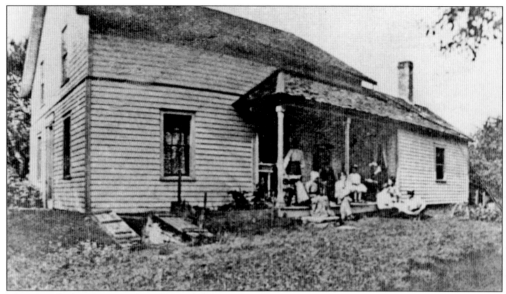

The Kneale family poses for a 1900 photograph on the porch of their house. The Richmond Road home still stands today, although the strawberry fields are long gone.

Annie Berg Case, top right, is at her home on Richmond Road at Hickory Drive in this 1920s photograph. Her family was instrumental in the founding of Case Western Reserve University in Cleveland, Ohio.

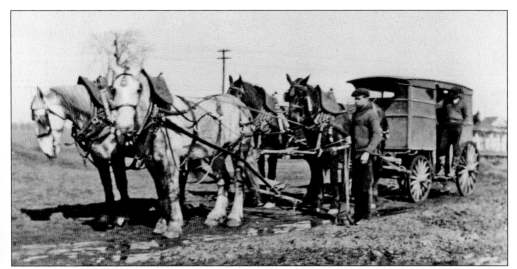

Brothers Roy (holding the horse) and Cliff Brainard had started their own bakery business. They are shown delivering to homes from their Star Bakery truck in this 1922 photograph.

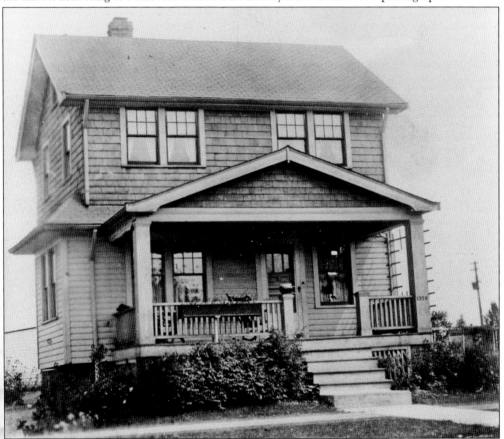

The Irene Road home of Lyndhurst village fireman Fred Wendel was built in 1926. The sale price was $5,200, and he and wife, Pearl, raised three kids there. Their son Fred Jr. later became the first president of the Brush High School Alumni Association.

Ralph and Ruth Simmons bought their Mayview Road home for $6,500 in 1934. The Lyndhurst housing boom had just gotten underway when the Great Depression occurred, and few homes sold again until after World War II.

Harry Brainard married Beryl Rush and built this home on the old tollgate site in 1915. It would later be the Wells-Kloss Funeral Home for decades.

Taken on a foggy Lyndhurst morning in the early 1930s, this photograph looks south from the front porch of Murial Mulac's home at the corners of Curry and Oakmount Roads.

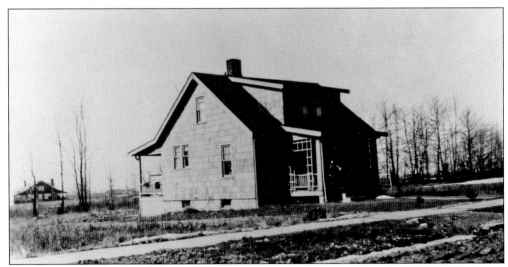

Hugh Sunderland took this photograph of his home, one of the first on an unpaved Irene Road, in 1926. Spencer Road, in the background, had already been paved the previous summer.

Neighborhood kid Hugh Sunderland and Paddy relax in front of his Irene Road home in 1940. Irene Road was paved by this time, but houses were still scarce until after World War II.

This 1927 view from a Spencer Road backyard looking south shows the fruit orchards that were prevalent during the early years. Houses on Mayview Road can be seen. This area would later become Thornbury and East Farnhurst Roads.

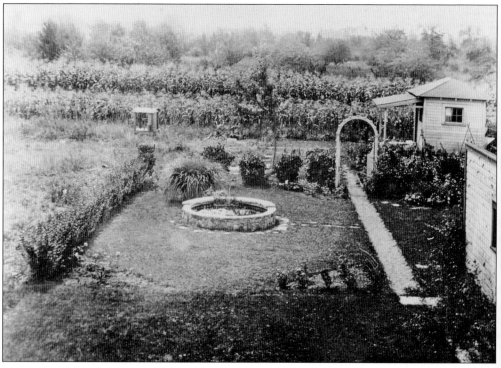

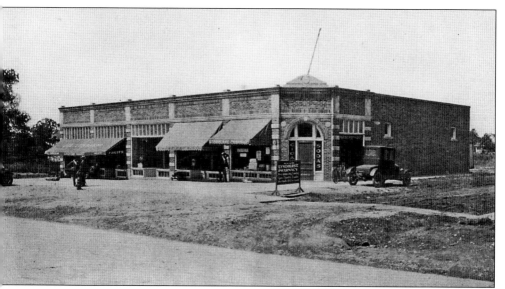

Lyndhurst's business center in the 1930s and 1940s was the group of stores located at Churchill and Mayfield Roads. Harry Guenther's drugstore, now owned by Victor Germ, occupied the eastern corner. It stayed the corner drugstore until the last owner, Dick Fitch, closed the pharmacy in 1991. An A&P grocery, Harry Sugarman's hardware store, a butcher shop, and the famed Oasis Café also shared the building.

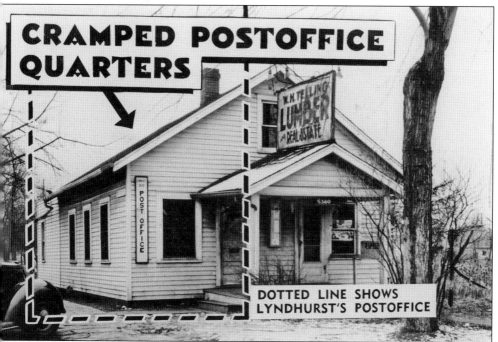

CRAMPED POSTOFFICE QUARTERS

DOTTED LINE SHOWS LYNDHURST'S POSTOFFICE

Directly across Mayfield Road from Vic Germ's drugstore was Walter Telling's Lyndhurst Realty. Even after beginning his Lyndhurst Lumber Company on Commodore Road in 1924, Telling maintained his office in this building, and he shared half of it with the U.S. Post Office for 10 years. Vic Germ's drugstore housed the post office until 1937, when it moved to this location. This photograph was taken December 15, 1947.

Paul Trump and his family took over the Lyndhurst Lumber business in the 1940s. This photograph shows the rear of the building in the 1930s. Originally opened as a contractor's source, it later became the area's retail lumberyard and is now operated by Trump's son-in-law Britt Raeburn.

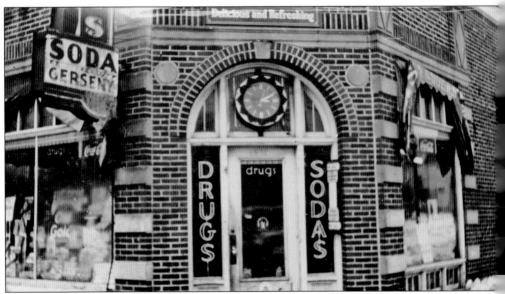

Peter Gerseny's drugstore, photographed on January 14, 1945, was originally opened by Mayor Harry Guenther. He sold it to Vic Germ, who then sold it to Peter Gerseny in 1940. Gerseny's white lab coat and neat moustache were remembered fondly by the Brush High students who enjoyed their cherry cokes at the all-marble soda fountain found along the east wall of the store.

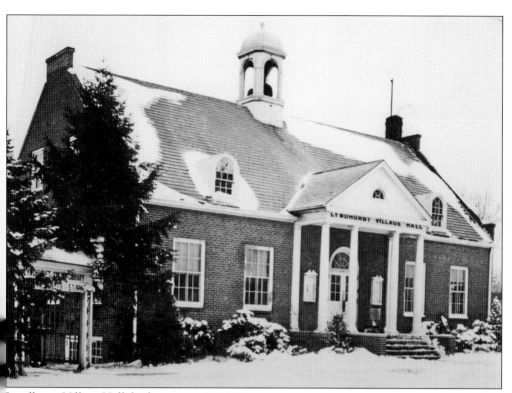

Lyndhurst Village Hall, built in 1926, housed the first library in the neighborhood in its basement. The entrance can be seen at the left.

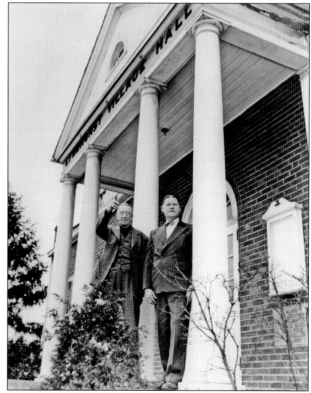

Lyndhurst service director Louis Emshoff points to gardening on the village hall front lawn as Mayor Elmer Elbrecht looks on. Mayor Elbrecht was elected in 1937 and was reelected seven times. He was an old-fashioned, hands-on type of mayor. In 1948, when the repair fund ran low, he pitched in with other village officials to repair some worn shingles and paint village facilities.

Many of the old-timers will remember the "mushroom concession stand" next to the pavilion in Lyndhurst Park. This young contestant was a winner of the Homedays bike parade and contest in the 1940s.

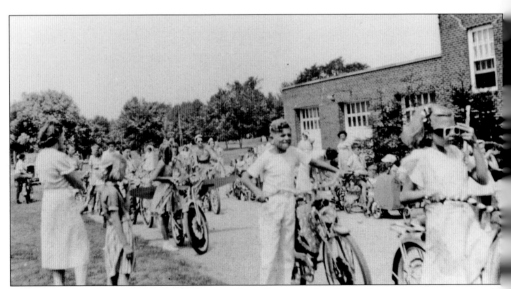

The annual Lyndhurst Homedays bike parade and contest has been the main attraction for the neighborhood kids since the inaugural edition and continues to this day.

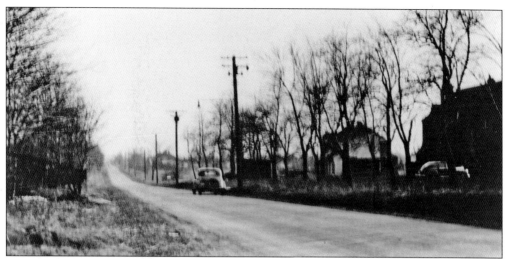

Brainard Road, pictured looking south from Mayfield Road in the 1940s, was a quiet country road at the time, but the community was ready to grow, and soon the farms would be gone.

Ann Meehan and a friend play in front of a Ridgebury Road home in 1947. Looking toward Irene Road in the southeast, new houses are under construction as postwar Lyndhurst begins to grow.

Edgefield Road, looking south from Mayfield Road, had sidewalks and room for growth in the late 1940s. This corner was the side track for the old C&E Interurban Railway cars until it was demolished in 1925.

Local photographer and Lyndhurst native Joseph Lazzaro took these pictures of his Lyndhurst Road neighborhood. His family was typical of many who moved to the country-like tranquility of Lyndhurst from their old ethnic enclaves in Cleveland, Ohio, during the 1940s and 1950s.

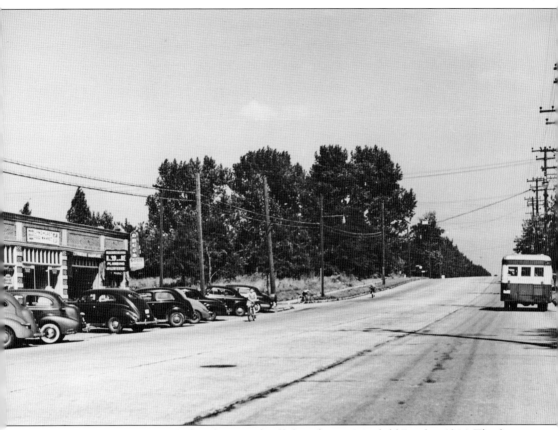

Local historian Cliff Noon took this photograph of bike riders on Mayfield Road in 1944. The first business block in Lyndhurst always had the local drugstore on the corner. Here it is in the Peter Gerseny era. Cain bus service supplied public transportation up and down Mayfield Road.

The northeast Ohio area has been called Hillcrest due to this hill on Ridgebury Road. Looking east from Ridgebury Road's western boundary at the creek on January 22, 1950, it would soon be completed west to Richmond Road.

Lyndhurst historian Cliff Noon said, "We were living on Irene Road at the time, which had construction going on. We parked on Spencer Road and walked back to the house. I stopped to take this picture looking west down Spencer Road in 1944."

The winter of 1950 was severe. Al Santos took this photograph of Maxwell's Mobile, at Parkview and Mayfield Roads, from his Lyndhurst Florist business across the street. Service director Karl Kreuz's house is to the right, next to the village hall.

In this 1955 Lyndhurst Service Department photograph looking east up Mayfield Road from Sunview Road, the community seems serene. It had changed from a village to a city in 1950.

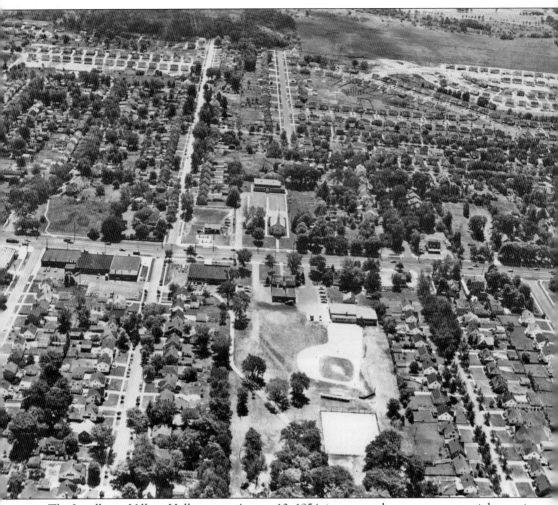

The Lyndhurst Village Hall area on August 13, 1954, is a great place to start an aerial overview. The village name was on the roof of each town's municipal building to help guide airplane pilots to their destinations. Lyndhurst Presbyterian Church is directly across the street. More landmarks will be pinpointed as Lyndhurst is explored by air.

Four

THE 1950S
AERIAL PHOTOGRAPHS

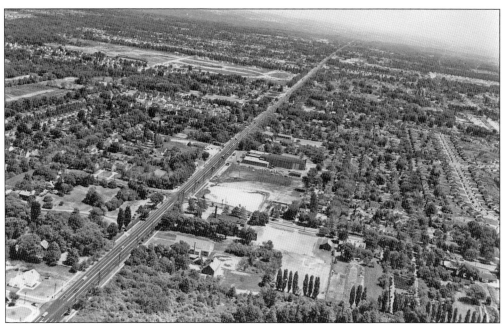

The late Bruce Young, an avid collector of greater Cleveland aerial photographs, graciously loaned his 4-inch-by-5-inch negatives, which the author hand printed. The resulting collection is a remarkable peek at a city's history. This August 13, 1954, photograph of the crossroads at Mayfield and Richmond Roads, looking east up Mayfield, shows the newly constructed Richmond movie theater. The construction area at the top left is the neighborhood surrounding Chester C. Bolton Elementary School.

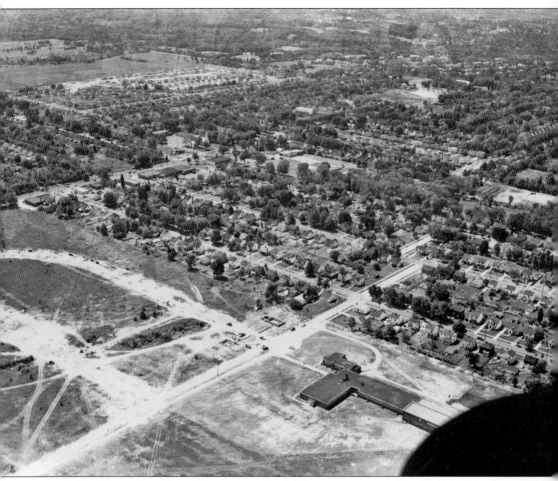

With the Chester C. Bolton Elementary School below, one can see the village hall in the upper center of this August 13, 1954, photograph. A ball diamond sits on the future location of the Lyndhurst Pool at right center. The Lyndhurst baseball team played out of the field behind the village hall.

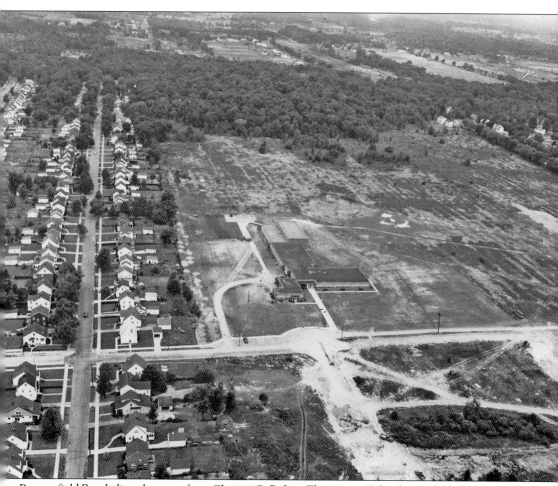

Beaconfield Road, directly across from Chester C. Bolton Elementary School, is at the land-clearing stage of construction on July 20, 1954. Gordon Road to the left has already filled in.

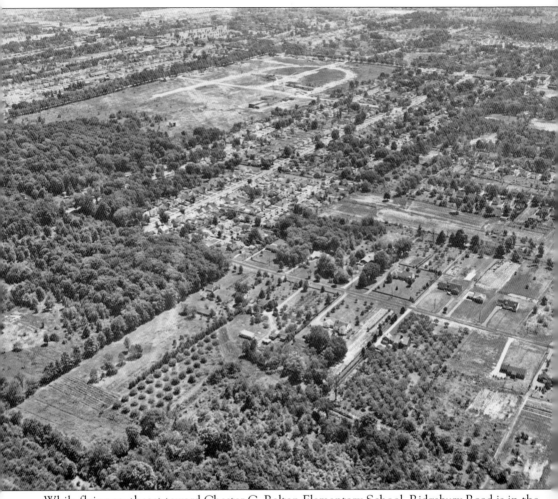

While flying southeast toward Chester C. Bolton Elementary School, Ridgebury Road is in the lower part of this August 13, 1954, photograph. The open field above it would become the site of Ridgebury Elementary School.

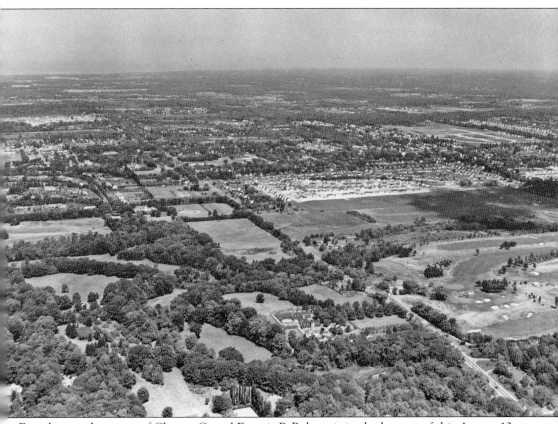

Franchester, the estate of Chester C. and Francis P. Bolton, is in the bottom of this August 13, 1954, photograph. Acacia Country Club is across Richmond Road, which is running north past Hawken School on the left to the crossroads with Mayfield Road.

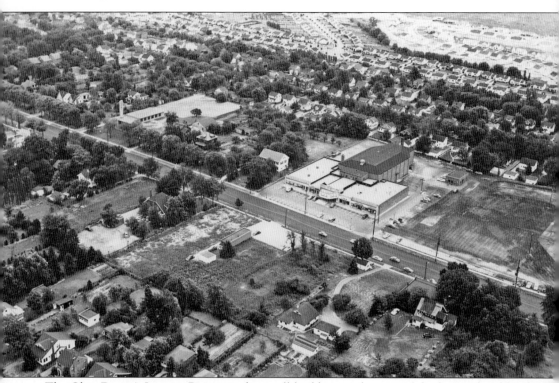

The Ohio Driver's License Bureau is the small building at the rear of the lot occupied by the Richmond Theater, built in 1948. This July 20, 1954, photograph shows the estate of Lyndhurst's first mayor, W. W. Toot, to the left, and Mayor Harry Guenther's house across the street.

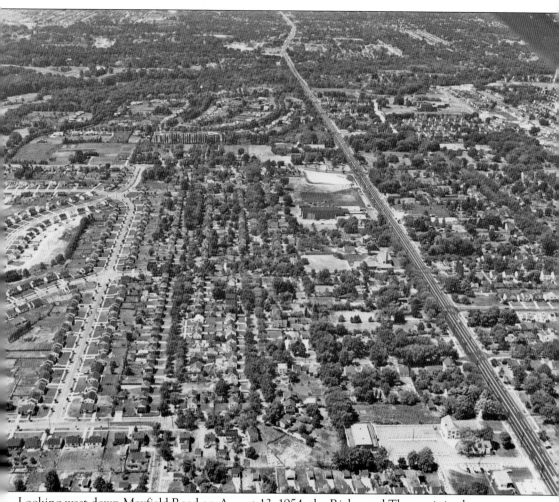

Looking west down Mayfield Road on August 13, 1954, the Richmond Theater is in the center. The clearing above it would become the site of Amy Joy Donuts, built in 1960. The Lyndhurst Park Estates and Hawken School are at the top left.

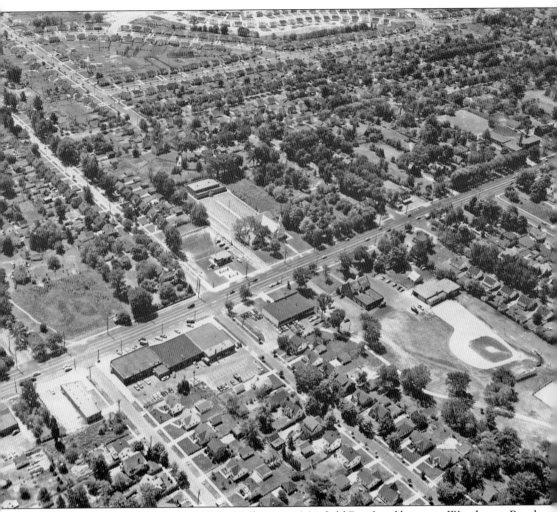

Irene Road, below Lyndhurst Village Hall, crosses Mayfield Road and becomes Winchester Road.
This line was the original western boundary of Euclid Township. In 1921, it was moved east to
the present boundary with Mayfield Heights, then Mayfield Township, at the urging of Lyndhurst
resident Alden Hare for business and political reasons.

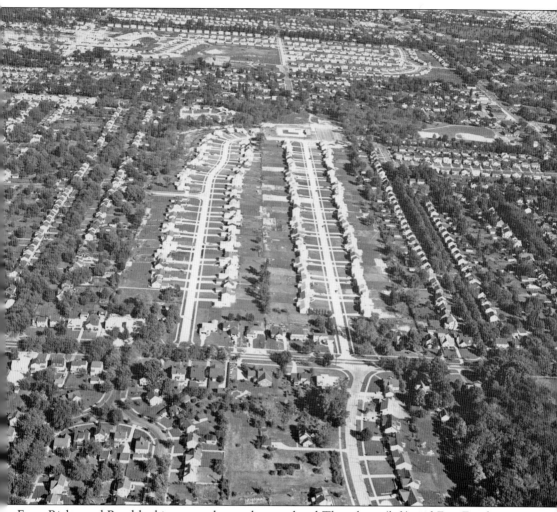

From Richmond Road looking east, the newly completed Thornbury (left) and East Farnhurst Roads connect to the Lyndhurst Pool construction in this September 29, 1957, photograph.

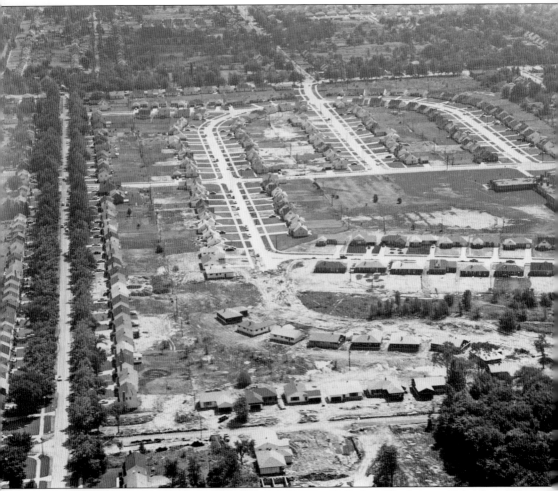

With Blanchester Road construction behind Chester C. Bolton Elementary School complete, Haverston Road construction continues on August 12, 1956. These new houses are located on what was the site of the old Cole Air Service hangar in the 1920s.

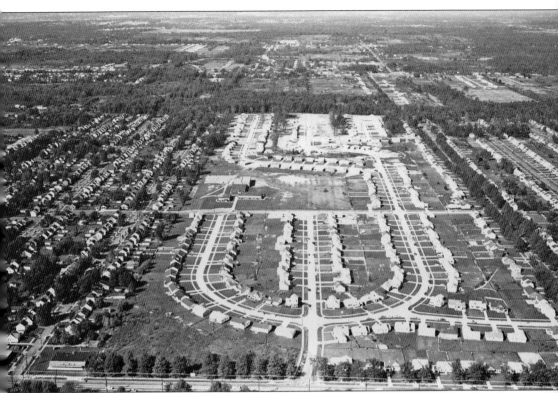

By September 29, 1957, construction of the Chester C. Bolton Elementary School area is complete. The author went to school here and fondly remembers Principal Fred Riegler and his friendly way with the kids.

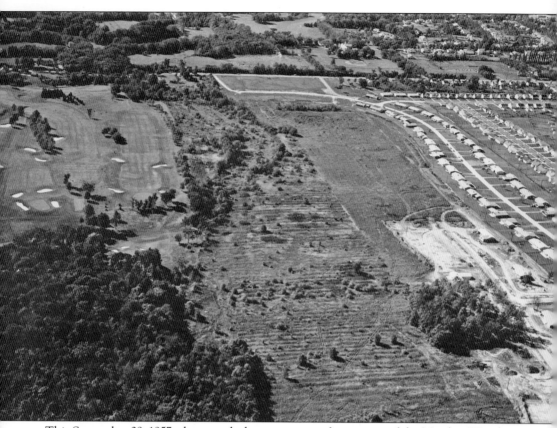

This September 29, 1957, photograph shows a western facing view of the Meadow Wood section in Lyndhurst under construction. Acacia Country Club is to the left, with Hawken School across the street.

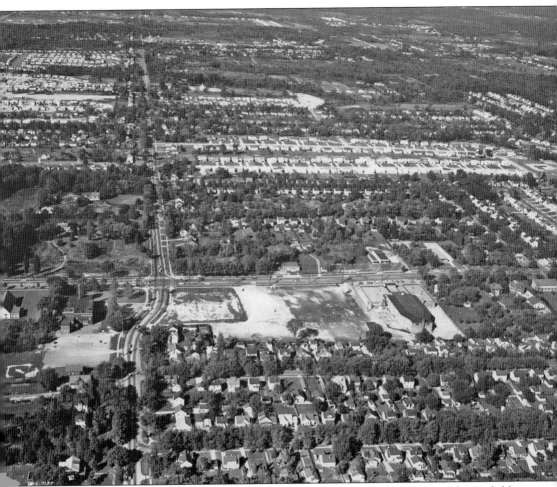

This photograph was taken looking north up Richmond Road from the crossroads with Mayfield Road on September 29, 1957. Mayfield Road has been a footpath, wagon trail, plank road, and interurban railway but had now become a busy highway through the Hillcrest area.

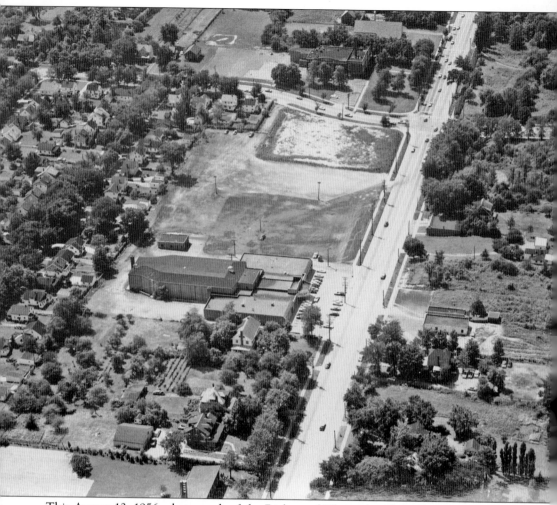

This August 12, 1956, photograph of the Richmond Theater, with its popular raffle drawings and Saturday matinee, was a favorite place for the neighborhood families. Built in 1948, it was razed in 2008.

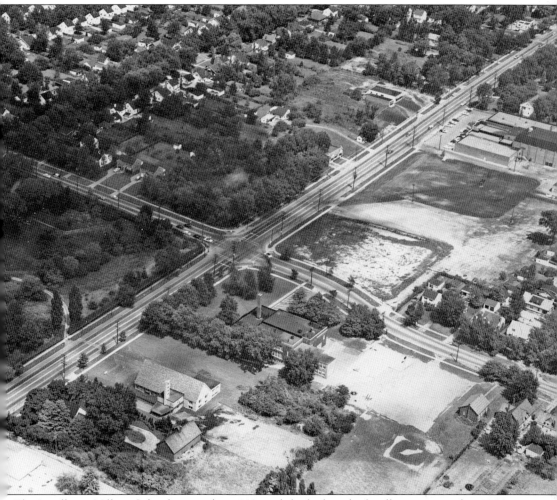

The Lyndhurst Village School, opened in 1922, and the little red schoolhouse, opened in 1866, are both in the center of this photograph. Lyndhurst's first schools, they were still in use at the time this photograph was taken on August 12, 1956.

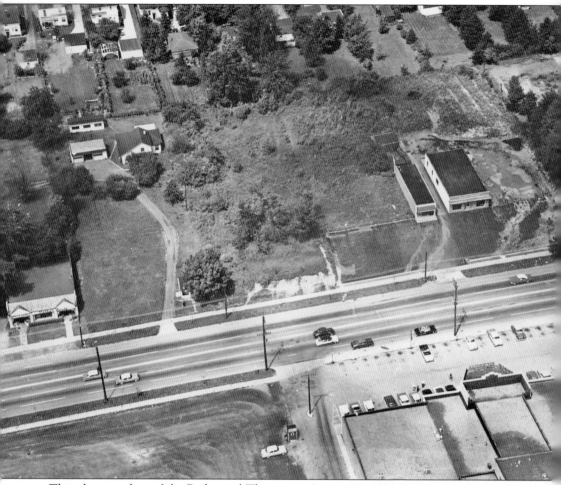

This photograph is of the Richmond Theater on August 12, 1956. Benny's Market and Parker House Furniture, at the bottom left, would later become the location of Tasty Pizza. The famed restaurant owned by the late Lyndhurst councilman Joseph Compola is a neighborhood landmark and is still owned by his family.

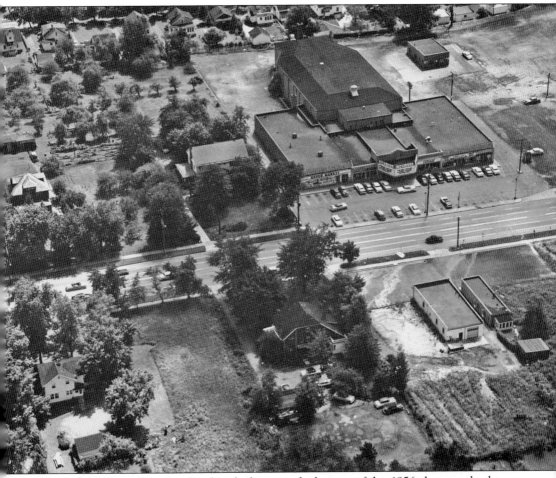

Lyndhurst mayor Harry Guenther lived in the house at the bottom of this 1956 photograph when he was elected to office in 1925. He sold his drugstore to Vic Germ and served the community well until voted out in 1931.

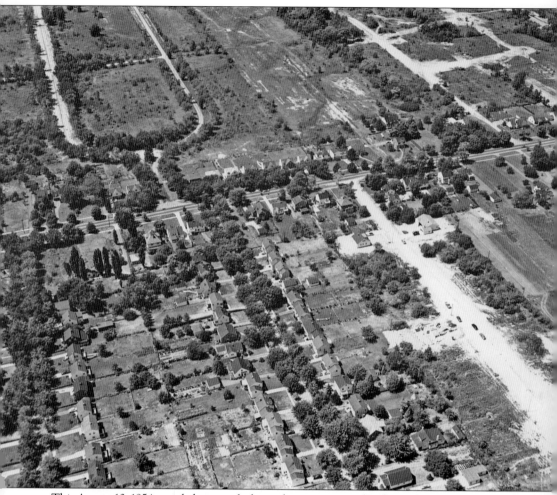

This August 13, 1954, aerial photograph shows the streets west of Richmond Road under construction. The Y-shaped roads are North and South Sedgwick Roads. To the right are Fairlawn and Emmet Roads. The road construction at the bottom is Kneale Road. This area was called "Skunk Hollow" at the end of the 19th century and was also Bert Gesing's neighborhood.

Five

BERT GESING'S NEIGHBORHOOD

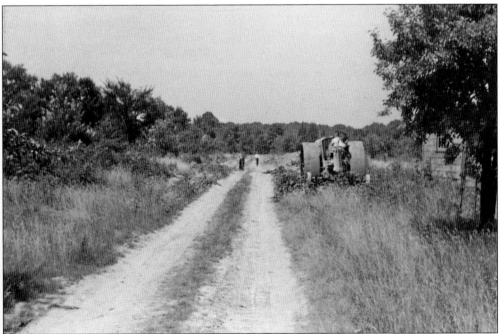

Bert Gesing was a Lyndhurst native who raised his family on the northwest side of Richmond Road. His photographic hobby produced many images of the young Lyndhurst community. While he passed on the photographic history to the author, there is no oral history. Because of that, the author has dated and located the images and shared what else he can. Sometimes a photograph is indeed worth a thousand words. This photograph was taken on August 7, 1954, from Richmond Road looking west down Emmet Road. The house on the right corner belonged to Ed and Emma Gruber, for whom the road is named.

Emmet Road construction continues; this view, taken August 7, 1954, shows the cleared roadbed.

This August 7, 1954, photograph shows Sedgwick Road before it split into its north and south forks.

This is a western view down Fairlawn Road from Richmond Road taken on August 7, 1954.

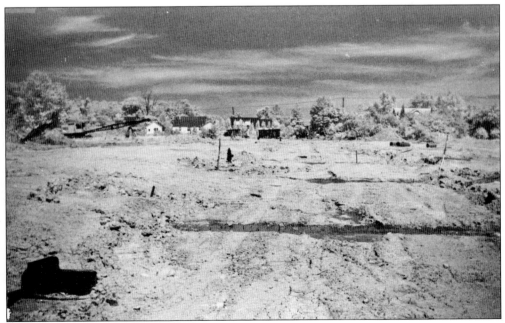

Emmet Road construction continues in this July 10, 1955, photograph. The land is being cleared for new homes. The houses in the background are on Richmond Road to the east.

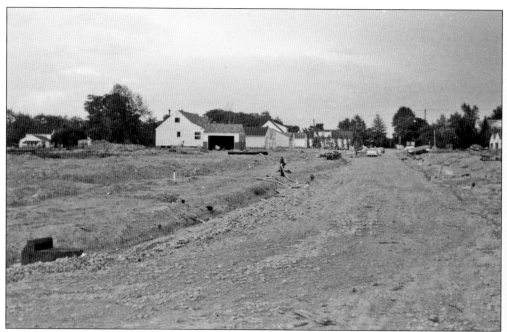

Emmet Road, in this view looking east, is progressing quickly, as this May 30, 1956, photograph will attest.

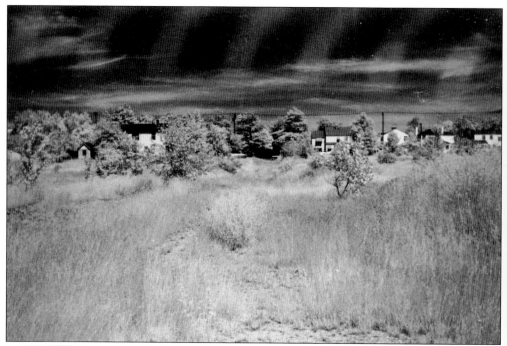

Fairlawn Road is in the early construction stage on July 10, 1955, looking east toward Richmond Road.

Professor Road construction is well underway in this August 1, 1956, photograph looking south from Anderson Road. Anderson Road is an old road through the area. Once a wagon trail, it connected the communities at Mayfield Township's eastern end with the west and the city of Cleveland, Ohio.

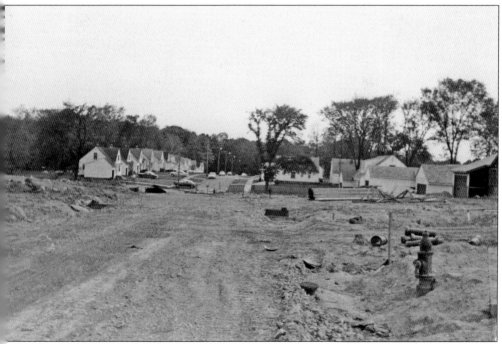

Ridgebury Road, looking west from Clearview Road on May 30, 1956, was now cleared from Richmond Road to Anderson Road. The building boom of the 1950s quickly filled this northwest corner of Lyndhurst.

The northern end of Lyndhurst shares Wilson Mills Road with Richmond Heights. Looking east from Richmond Road, Wilson Mills Road was still two lanes and quiet in this March 10, 1955, photograph. The Richmond family gave the road and city, previously called Clarabel Village, their present names.

Bert Gesing's neighborhood was underway to the modern era. All dirt roads and trails were becoming a thing of the past. This 1950 photograph is of the west end of Ridgebury Road before it finally reached Richmond Road. The local kids called it "the Indian trail" and followed it to its eastern border at SOM Center (Solon, Orange, Mayfield Center) Road in Mayfield Heights.

Six

THE MODERN ERA

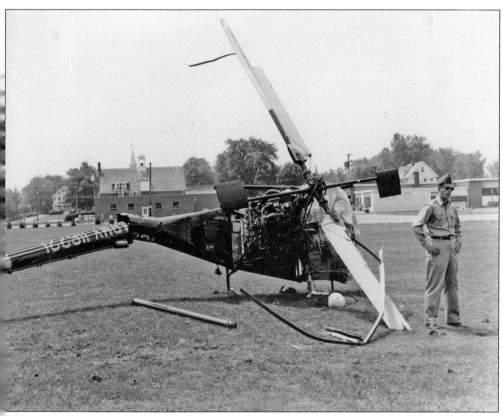

The 1960s started with a bang, as this army helicopter crashed during the 1961 Lyndhurst Homedays. No one was hurt, but the contrast between the modern helicopter and the village hall was significant as Lyndhurst entered the dawning of a new age.

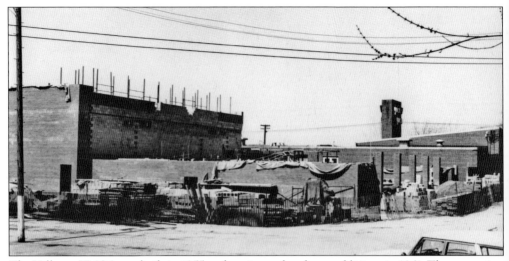

The Hillcrest YMCA was built in 1955 and got its pool and gym additions in 1961. The expansion was necessary to serve the swiftly growing community.

The curved section of Richmond Road in front of the Village School south of Mayfield Road gets straightened out in 1961.

Road improvement was of primary importance as the Lyndhurst population grew. The intersection was modernized to accommodate the added traffic. In 1961, National City Bank construction was started on the northwest corner, where the Horatio Ford estate once stood.

National City Bank rises during its 1961 construction on the northwest corner of Richmond and Mayfield Roads. It is still in operation today.

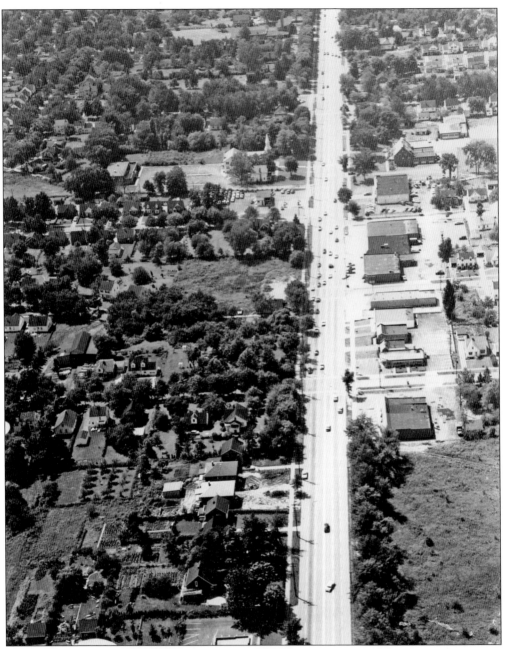

The Lyndhurst Village Hall area underwent considerable change during the 1960s. This August 12, 1956, aerial photograph shows the future site of Ianni's BiRite food store, still a grove of trees on the southeast corner of Winchester and Mayfield Roads. Sun Oil, the gas station built in 1953, sits directly across Winchester Road on the southwest corner.

Dr. George B. Nelson, one of Lyndhurst's earliest doctors, lived in this house on the same corner that Ianni's would build their new food store. The house was razed in 1961. Also lost was the old skating pond to its left. This photograph was taken from the front of the old village hall.

This 1965 view of Ianni's BiRite food store was also taken from the front of the village hall. Their deli was a place a kid could get a sample slice of cheese from one of the brothers.

The three Ianni brothers, from left to right, Joe, Iggy, and Chuck, moved across the street from their original Lyndhurst Food Fair location on the northeast corner of Irene and Mayfield Roads.

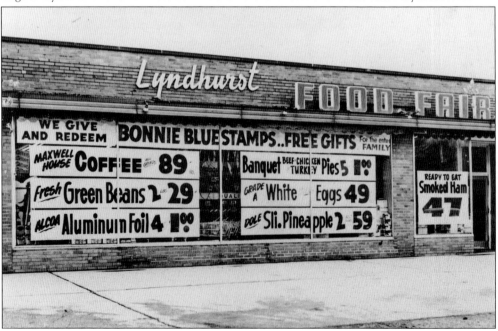

Lyndhurst Food Fair, Lyndhurst's first "supermarket," displays its prices on its front window. If only those prices were still in effect!

In 1929, Mr. and Mrs. Peter Piccino bought a florist business that had three greenhouses on Sunview Road. They added four more and named their new business Lyndhurst Florist. After World War II, Al Santos, Mrs. Piccino's son, designed the store that stands today as busy as ever on Mayfield Road. Lyndhurst Florist is still run by his son Thomas Santos with help from sister Sandra. The late Al Santos had the local VFW post named in his honor.

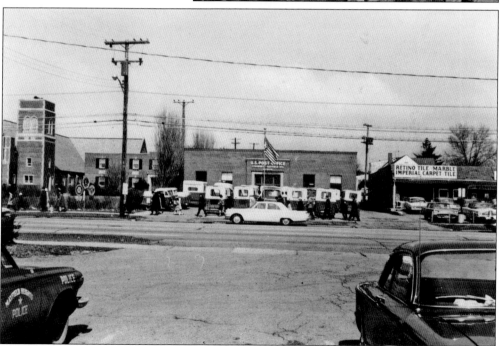

This Lyndhurst Post Office was built in 1954 and was the fourth of six locations over 85 years. St. Clare Catholic Church stands to the left in this March 22, 1964, photograph.

Lyndhurst's first mayor, W. W. Toot, lived in this house on Mayfield Road. This May 16, 1972, photograph shows O'Brian Chevrolet, built to the right in 1966.

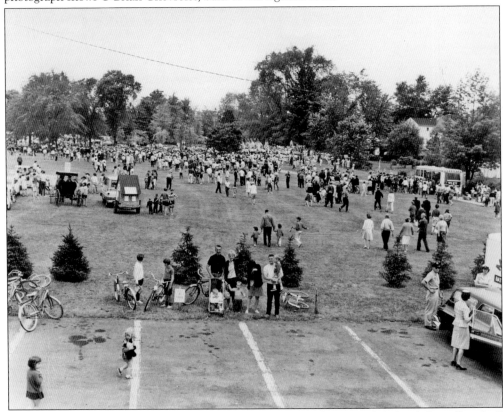

This 1967 photograph of Lyndhurst Homedays, held in Lyndhurst Park behind the village hall since 1926, had grown to two days in the modern era. In 2010, it has grown to three days, as the Friday night dance for Brush High students was added in the 1990s.

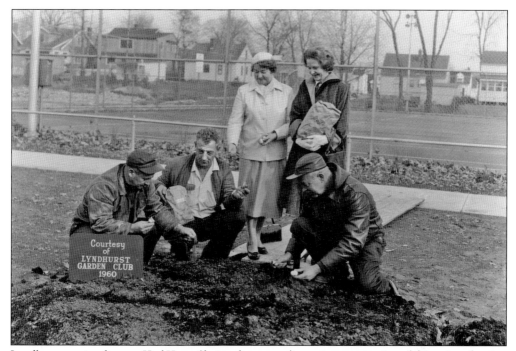

Lyndhurst service director Karl Kreuz (facing the camera) oversees preparation of the spring planting in Lyndhurst Park in conjunction with the Lyndhurst Garden Club. Started in 1937 to promote civic spirit, the garden club still has its annual plant sale in the park, a neighborhood favorite.

The Lyndhurst Pool, built in 1955, stands ready as the park undergoes renovation in this 1957 photograph. Lyndhurst Village Hall is at the top left. The path through the park covered up Lyndhurst Creek, a branch of Euclid Creek, where flooding was an occasional problem.

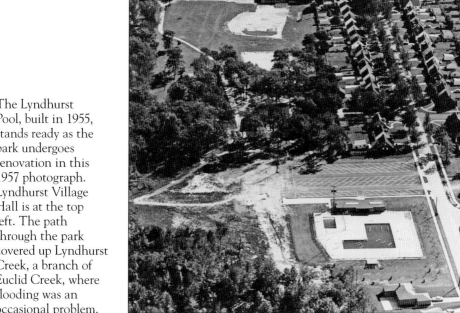

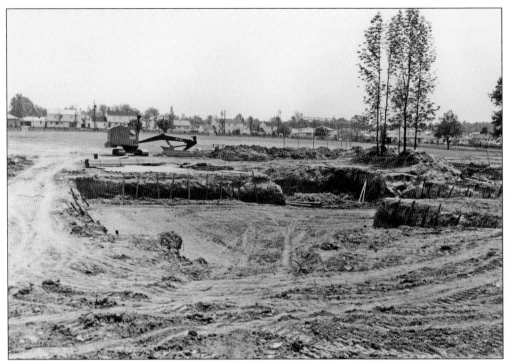

Lyndhurst had grown so fast that a second municipal pool was needed. Work is well underway on Brainard Pool in this June 22, 1966, photograph. Lyndhurst Road is in the background.

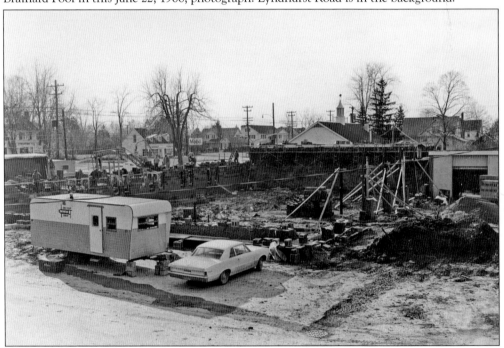

The construction of the new mechanic's garage in front of the old service building was begun in 1967. Lyndhurst Florist, on Mayfield Road, is in the background. Maxwell's Mobil is to the west of the construction.

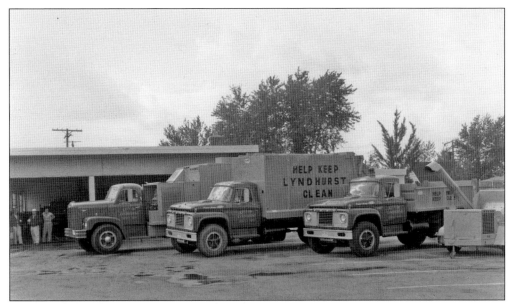

The Lyndhurst Service Department had a fleet of three trucks in 1967: the red "Sanivac" on the left and the two Fords on the right. The service department director was Karl Kreuz, whose son Karl Jr. would take over that roll years later.

In 1989, construction of the new service building was completed. It also incorporated the Lyndhurst Building Department under the direction of Thomas Kunz.

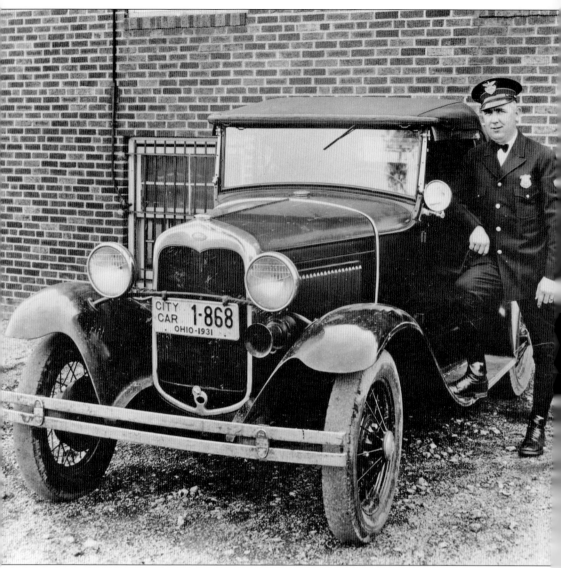

George Brueggemyer was elected village marshal on November 5, 1929. Lyndhurst's first police chief was Arthur Johnson, who with deputy Ernest Jones served for decades protecting the residents.

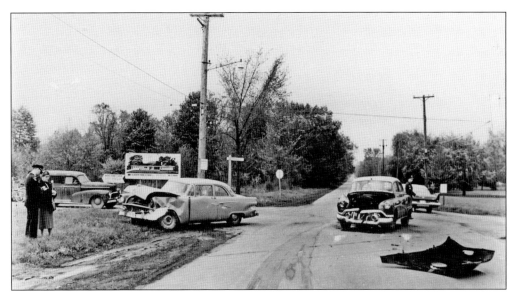

Lyndhurst police lieutenant Lloyd Brown takes a statement at this accident scene on May 14, 1959. The Alberta Park Estates sales sign is on the northeast corner of Brainard and Cedar Roads.

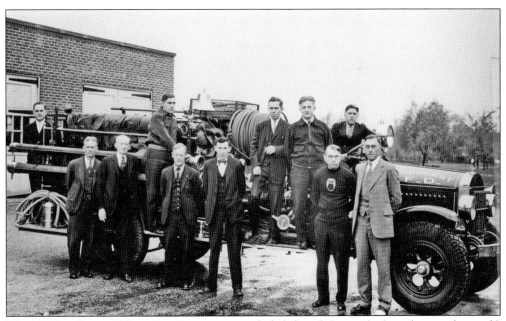

The 1932 Lyndhurst Village Fire Department included, from left to right (standing on the truck) Clarence Rist, R. Robinson, Jim Sykes, Carl Oltman, and Earl Oltman; (standing on the ground) George Guptil, E. Magruder, Scotty Roughton, Carl Sutter, Fred Dittmar, and Fred Wendel Sr.

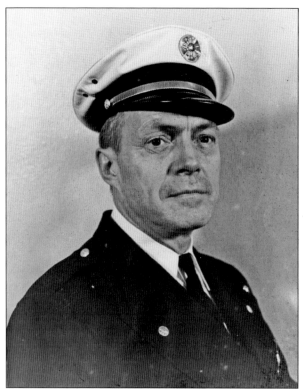

Fire chief William "Bill" Kingzett took over on December 10, 1941. Under his direction and with the help of Carl Sutter and Ted Gilbride, the department began to grow. They expanded the fire training program and upgraded the equipment. During the 1950s, seven full-time firemen and 16 auxiliary men manned the station 24 hours a day.

This August 1973 photograph is the last taken of the old Lyndhurst Village Hall before the new city hall was built in 1974. The new building would collectively house the police and fire departments as well as the city offices and the area court facilities.

Steve Roth was appointed fire chief in 1973, as the ranks of the full-time firemen swelled to 23. With the added manpower, he established the first paramedic program in the area. Chief Roth oversaw the purchase of the city's first aerial ladder and then retired in 1980. Joseph Sweeney took over as chief and continued the modernization.

In 1954, the Lyndhurst Fire Department became involved in emergency medical services with the addition of this 1946 Cadillac ambulance. The EMT services proved so popular that a second ambulance, a new Cadillac, was purchased in 1959.

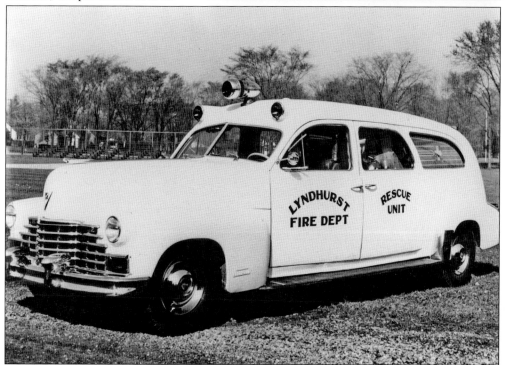

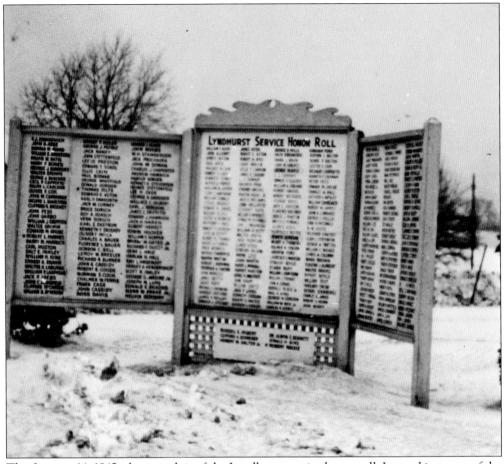

This January 14, 1945, photograph is of the Lyndhurst service honor roll. It stood just west of the village hall but was lost when the new municipal center was built in 1974.

The last days of the Lyndhurst Village Hall were upon it, as the police and fire departments had outgrown the west wing addition. Maintenance problems, including flooding in the basement jail, necessitated a modern building. This photograph was taken on November 5, 1971.

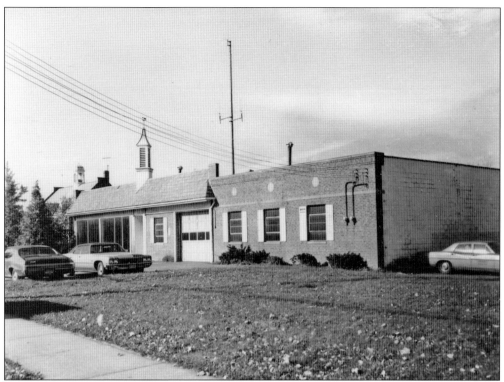

Lyndhurst Motor Sales, the eastern neighbor of the village hall since 1950, was also razed for the construction of the new municipal center.

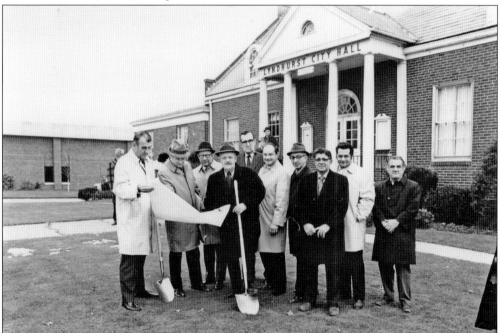

Mayor Lester Ehrhardt wields the shovel at the November 26, 1971, groundbreaking for the new Lyndhurst City Hall.

One last photograph of Lyndhurst Park was taken from the roof of the old village hall on December 10, 1971. The ball diamond was still in use.

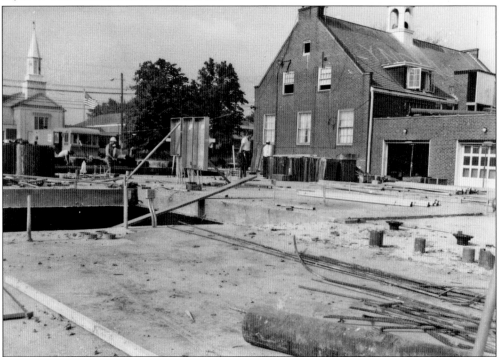

Construction of the new Lyndhurst City Hall is underway in this June 15, 1972, photograph. Business was still conducted from the village hall until completion in 1974.

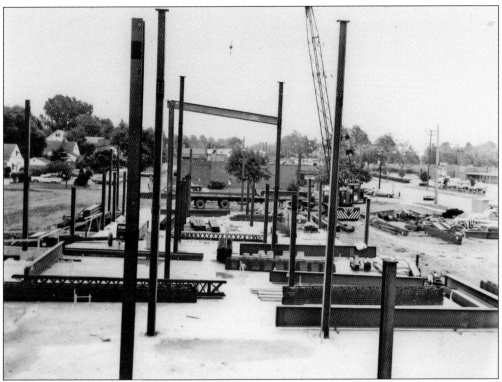

Looking east from the roof of the village hall, construction of the fire department is seen on August 2, 1972.

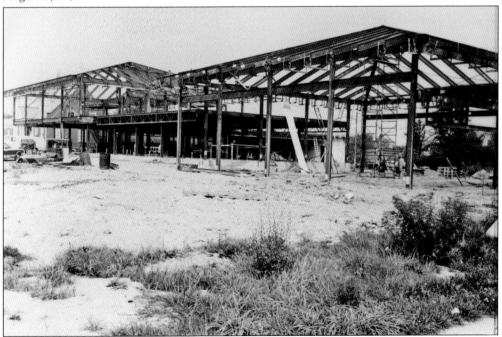

Construction continues on September 4, 1972, as the new Lyndhurst City Hall takes shape. This photograph was taken from the northwest corner of Irene and Mayfield Roads.

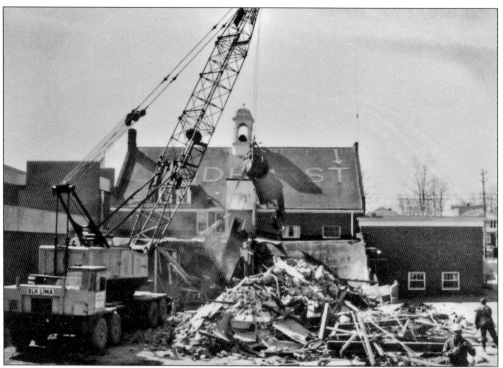

On April 16, 1974, the old Lyndhurst Village Hall is razed, and the new city hall stands poised to take over. Pilots would no longer be able to navigate the area by following the village names printed on the roofs of their respective towns.

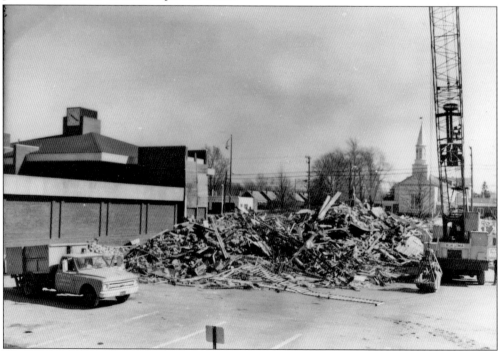

The last vestiges of the old Lyndhurst Village Hall were hauled away on April 16, 1974.

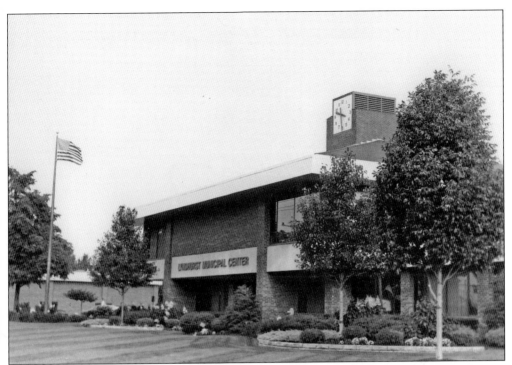

Lyndhurst now had a modern municipal center housing the government, police, fire, and court. The Lyndhurst Creek, which was beneath the old building, was rerouted, and flooded basements were a thing of the past.

Leonard Creary was elected mayor of Lyndhurst in 1980. He ran a tight fiscal ship and was easily reelected many times until his retirement in 2001.

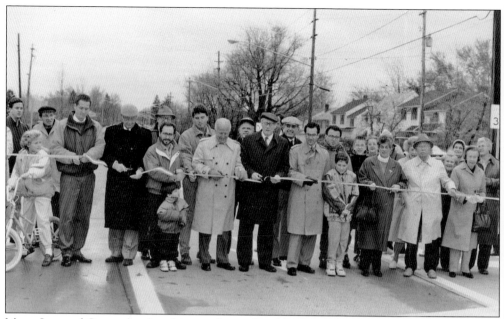

Mayor Leonard Creary (in the white coat) cuts the ribbon at the November 19, 1991, dedication of the Brainard Road reconstruction. To his right are the mayor of Lyndhurst in 2010, Joseph M. Cicero Jr., and his son Tim watching the proceedings.

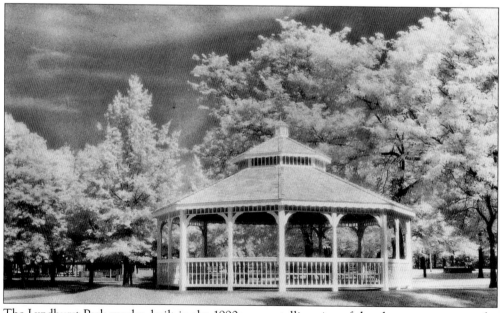

The Lyndhurst Park gazebo, built in the 1990s, was a telling sign of the changes to come at the turn of the century. The pavilion in the background was next to be razed.

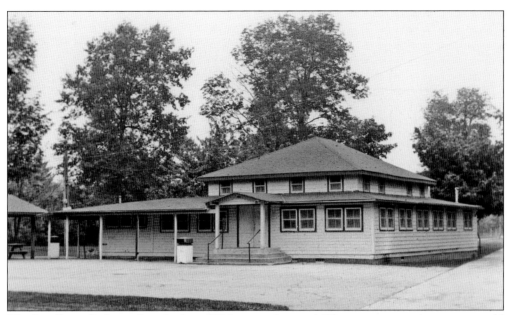

The Lyndhurst Park pavilion, built in 1926, was to be razed. The new community center would be built on the same site. Many old-timers took one last tour of the familiar old building that once housed so many childhood memories.

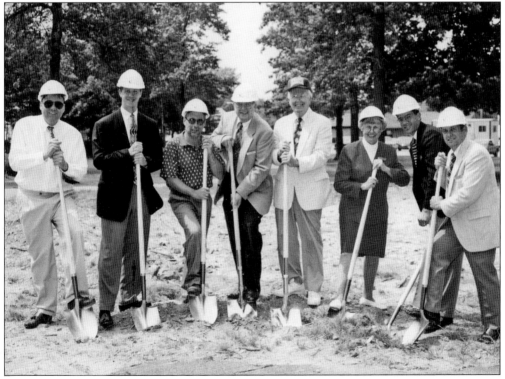

Ground was broken for the new community center on July 8, 1997. From left to right are council members Marty Puin, Barry Jacobson, Joe Cicero, Leo Lombardo, Mayor Leonard Creary, Eunice Horton, Patrick Ward, and Dale Fisher.

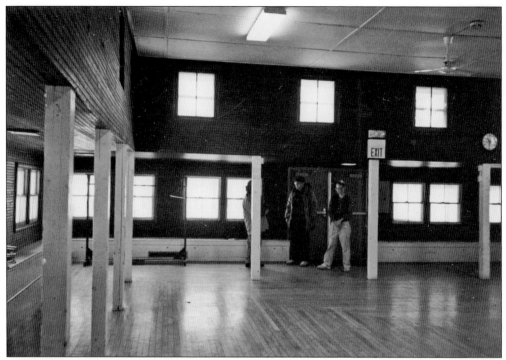

In February 1997, neighborhood old-timers came for one last look inside the Lyndhurst Park pavilion. This southern view is the front of the pavilion.

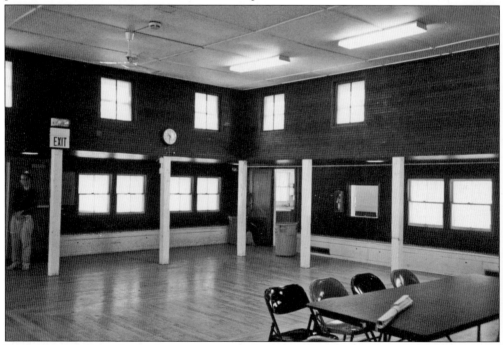

Inside the pavilion, the kitchen area was easily accessible. The hardwood floors saw many things through the years. One strip was installed inside the new community center as a historical memento.

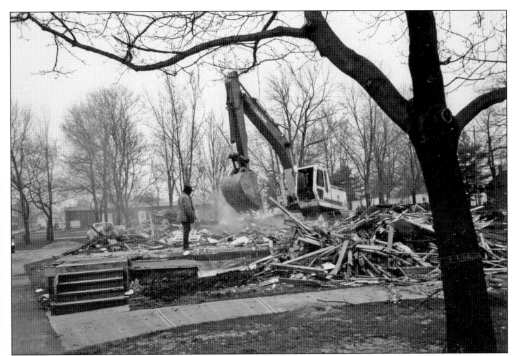

Demolition in April 1997 brought the historical building down forever. Older neighborhood kids fondly remember SELREC (summer recreation) classes held in the pavilion. Homedays committee members recall the "granddaddy" of all skunks sauntering out from beneath the building at Homedays one year.

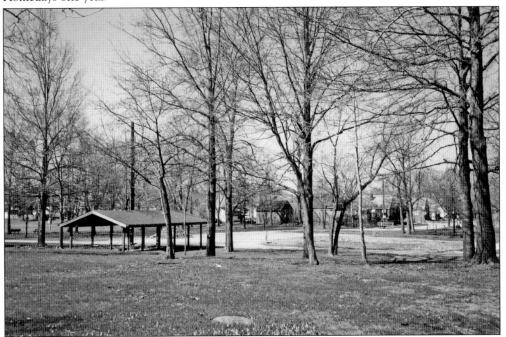

The empty lot where the pavilion stood waits for the new community center to be built on the same spot.

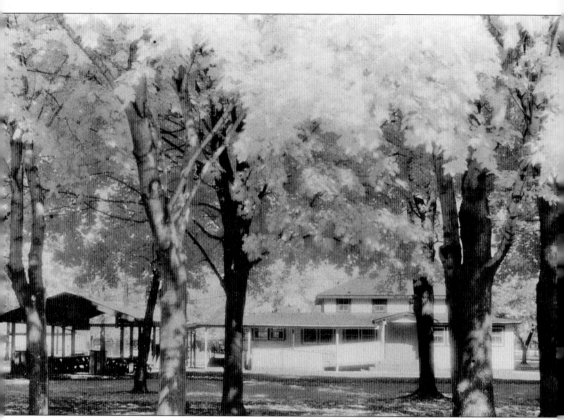

When the Lyndhurst pavilion was razed, it seemed as if a bit of childhood and innocence was snatched away. This dreamy infrared photograph recalls the "good old days" in Lyndhurst Village and was the motivation for this book.

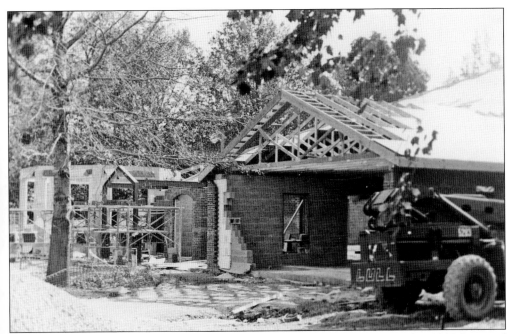

Construction of the new Lyndhurst Community Center was begun in September 1997. It moved swiftly, as this October 12, 1997, photograph demonstrates.

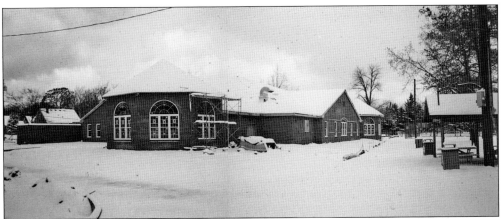

By November 16, 1997, the Lyndhurst Community Center, as viewed from the park, was already a beautiful structure.

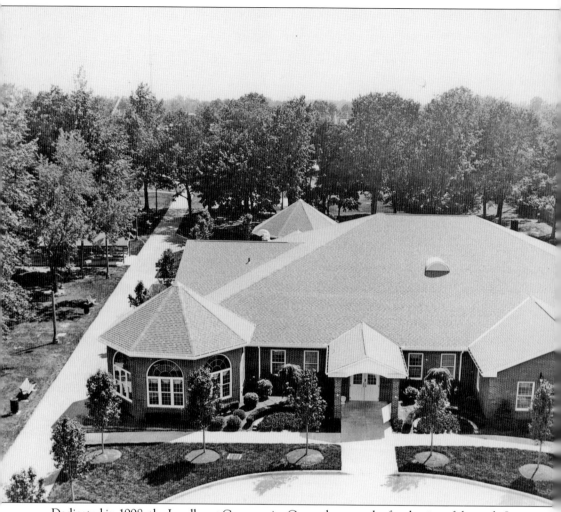

Dedicated in 1998, the Lyndhurst Community Center became the focal point of the park. Its main hall is lined with huge photographs of old Lyndhurst, adding to the hometown charm of the new building. This aerial ladder view of the shady park gives that same old-time feeling.

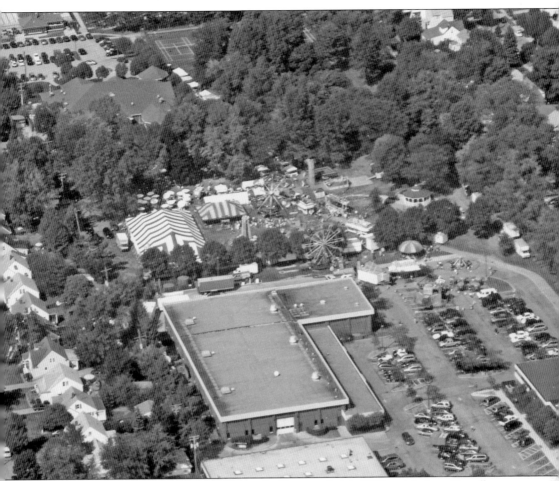

Lyndhurst service director Rick Glady and his wife, Chris, took this 2005 aerial view of Lyndhurst Homedays. From the modern service building in the foreground to the municipal pool in the background and Lyndhurst Park between them, this property has always been the heart of the community.

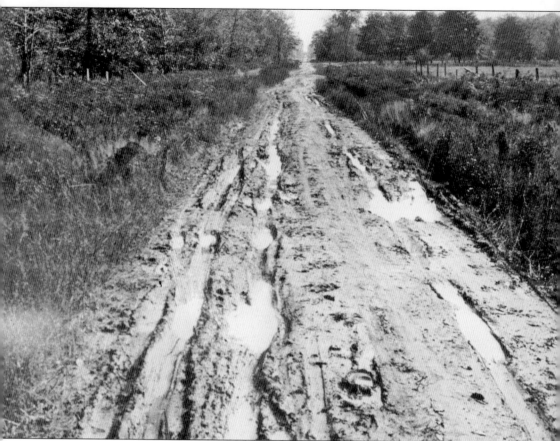

Taking a break from the modern era, this photograph goes back to the rural Lyndhurst period. Of all the author's collection, this is one of his favorite photographs. Taken in 1928, this view is of Cedar Road looking east from Brainard Road. Now a hectic freeway exit, it used to be an important wagon road out of the Chagrin Valley. Cedar Road west would take travelers to Richmond Road and the Bolton estate.

Seven

PEOPLE, PLACES, AND THINGS

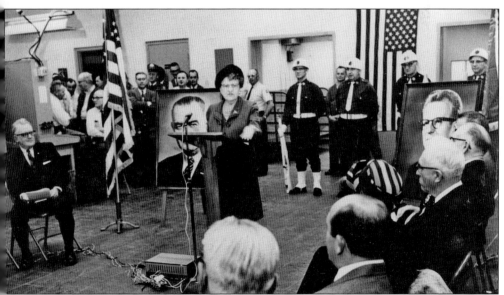

As Lyndhurst grew through the years, certain people and circumstances greatly influenced the community. None was more prominent than Francis Payne Bolton, Lyndhurst's first lady. Married in 1907, she and husband Chester C. Bolton built their estate, Franchester, on Richmond Road in 1916. While husband Chester pursued his interest in raising dairy cattle, Francis pursued her interest in nursing. In 1923, she provided the endowment to establish the Western Reserve School of Nursing, the first in America to be associated with a university rather than a hospital. The school was named in her honor in 1935. They both served in the U.S. Congress, Frances filling Chester's chair after his death in 1939. She won 14 succeeding elections until her retirement in 1968. She died at her beloved Franchester on March 9, 1977. Here she is seen dedicating the new Lyndhurst Post Office in 1967. Mayor Lester Ehrhardt, at the far left, listens intently.

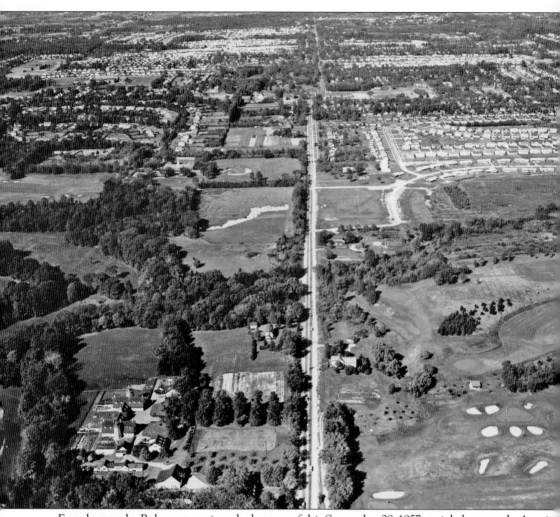

Franchester, the Bolton estate, is at the bottom of this September 29, 1957, aerial photograph. Acacia Country Club is across Richmond Road and the newly developed Meadow Wood community is just to the north. Hawken School, at the top left, was built on land donated by Francis Payne Bolton.

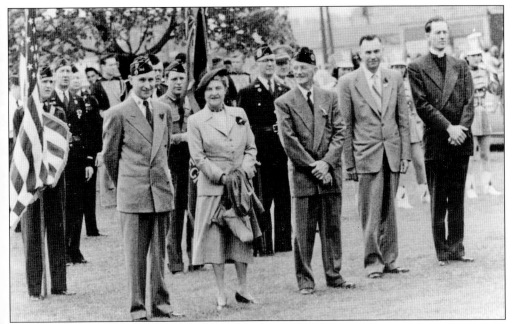

Francis Payne Bolton was the honored guest at this VFW Memorial Day parade. To her right is Hugh Sunderland, who took many photographs of Lyndhurst as a young man. Second from the right is South Euclid mayor George Urban, who served from 1948 to 1971.

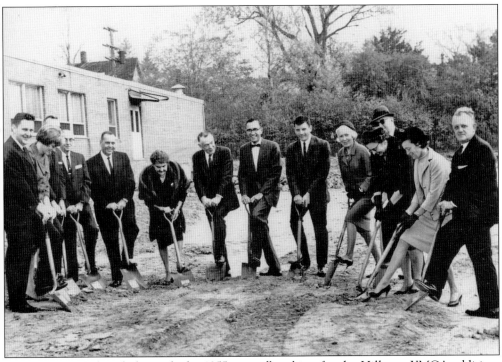

Francis Payne Bolton helps with the 1955 groundbreaking for the Hillcrest YMCA addition. Mayor Lester Ehrhardt is at the far right.

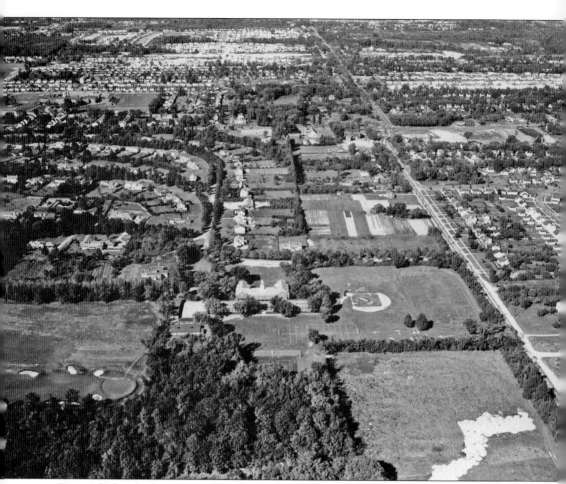

Dissatisfied with the existing Cleveland schools, Francis Payne Bolton became interested in the methods of teacher James Hawken. She donated a parcel of land on the north end of Franchester and established Hawken School in 1915. The Hawken School campus and Lyndhurst Park Estates are in the lower center of this June 3, 1955, photograph.

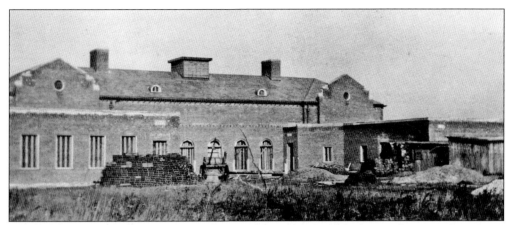
This photograph is of the 1916 construction at Hawken School in the Lyndhurst Park Estates.

With the opening of Hawken School, the country-like Lyndhurst Park Estates began to fill. This photograph, facing northwest from the rooftop of the Hawken School in 1924, shows some of the large garden plots popular in the area.

This northeast view from the Hawken School roof in 1926 is of the Frederick Wischmeier farm, built in 1850.

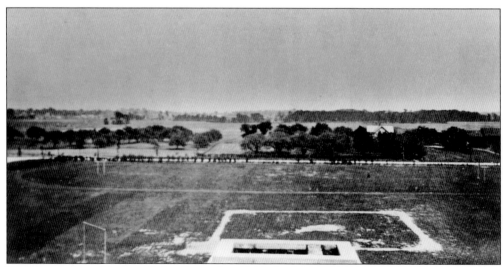

Facing east from Hawken School's roof in 1927, the Meadow Wood Estates have yet to be constructed. Richmond Road runs through the middle of this photograph.

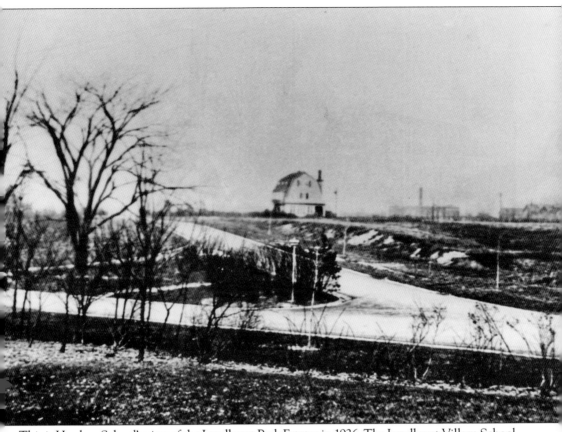

This is Hawken School's view of the Lyndhurst Park Estates in 1926. The Lyndhurst Village School at Richmond and Mayfield Roads can be seen at the top right. The area was just beginning to fill when the Great Depression began. Construction stopped until after World War II. Victory gardens were extremely popular through this era. The Bolton family would donate plots of land to anyone who wanted to keep one of these gardens.

The hills found on Mayfield Country Club directly behind Hawken School were a popular place for the neighborhood kids to enjoy winter sled riding. Notre Dame College in South Euclid can be seen just past the hills in this 1928 photograph.

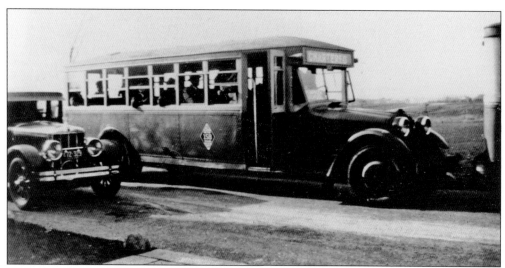

This school bus, which daily brought both students and faculty to Hawken School, was necessary after the C&E Interurban Railway ceased operation in 1925. Riders would get off the "Big Red" interurban cars on Mayfield Road and walk down to the school.

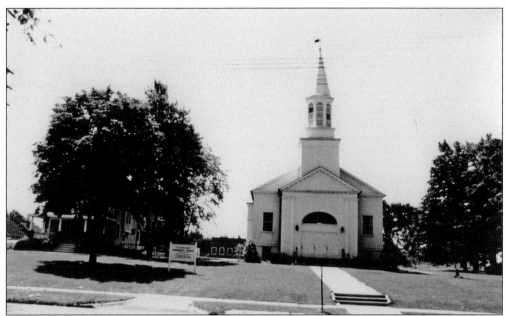

There was no church in the village until Lyndhurst Presbyterian Church was founded in 1941. In 1928, Dr. George A. Mackintosh held services in the Lyndhurst Village Hall. The congregation was started and met there for the next 12 years. The late 1930s brought a movement to start a church building, and construction began in 1940.

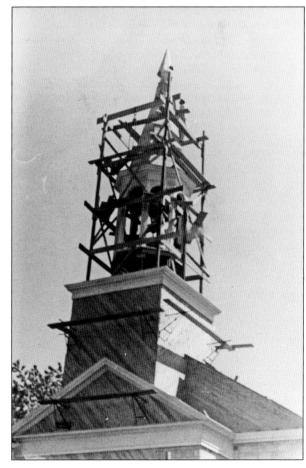

The carillon in the church tower was purchased with public contributions and dedicated "to the memory of those who gave their lives and to those who served their country from the Village of Lyndhurst" in World War II. This July 18, 1941, photograph shows the steeple near completion.

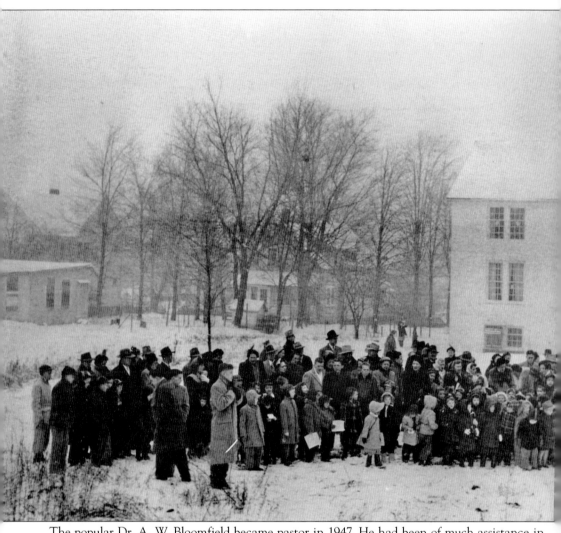

The popular Dr. A. W. Bloomfield became pastor in 1947. He had been of much assistance in organizing and financing the new church. Under his guidance, membership had increased to 700.

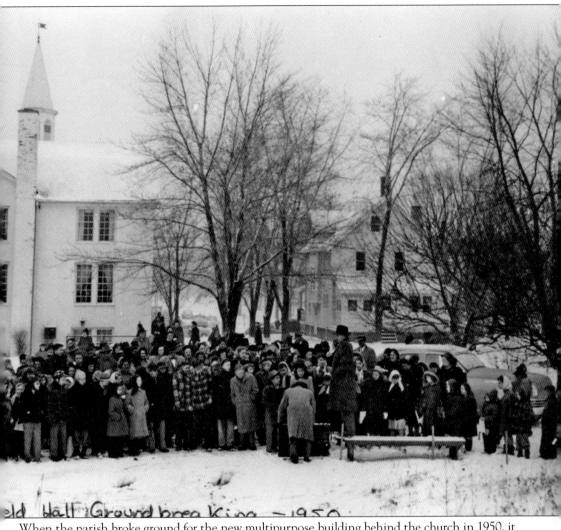

eld Hall Ground breaking — 1950

When the parish broke ground for the new multipurpose building behind the church in 1950, it was dedicated in his honor.

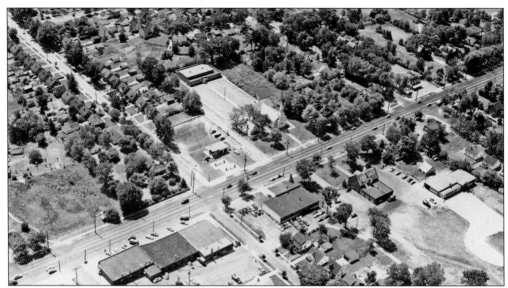

The 1950 addition of Bloomfield Hall to Lyndhurst Presbyterian Church is seen in this August 13, 1954, aerial photograph.

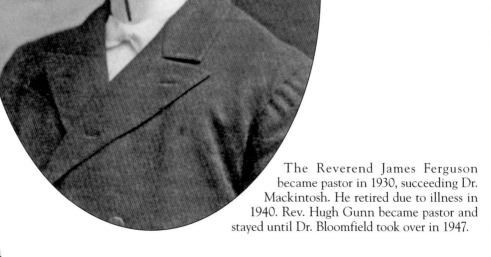

The Reverend James Ferguson became pastor in 1930, succeeding Dr. Mackintosh. He retired due to illness in 1940. Rev. Hugh Gunn became pastor and stayed until Dr. Bloomfield took over in 1947.

In 1944, Lyndhurst acquired its second church with the establishment of St. Clare's Catholic parish by Archbishop Edward F. Hoban in a stucco former clubhouse on the edge of the Lyndhurst Golf Course property. The half-acre was purchased for $18,000, and the first mass was said by Rev. Fr. J. W. Fitzgerald on October 15, 1944.

The abandoned Lyndhurst Night Club, photographed on the property on March 4, 1949, was remodeled into a church with a seating capacity of 350 and a two-room school. The church was furnished with donations from St. Catherine's and St. James's parishes. Neighborhood parishioners remember the stifling hot summertime masses, where fainting during the sermon was a common thing.

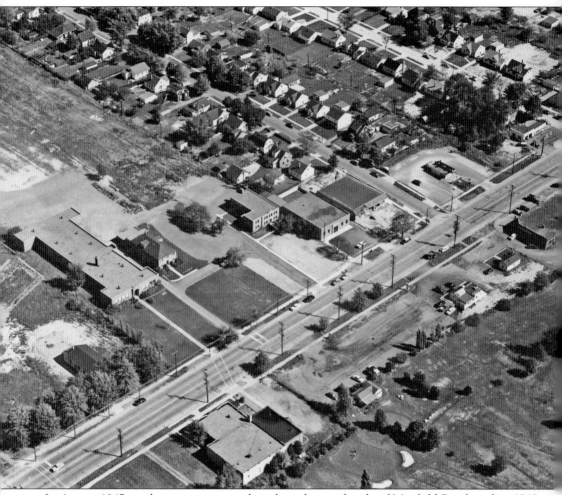

In August 1945, twelve acres were purchased on the north side of Mayfield Road, and in 1949, the St. Clare School was completed with four classrooms. In 1950, seven more classrooms were added, and all the students previously taught in the church were transferred to the new school. The Lyndhurst Post Office, opened in 1948, is on the right. The Lyndhurst Golf Course is across the street surrounding the church in this September 24, 1953, photograph.

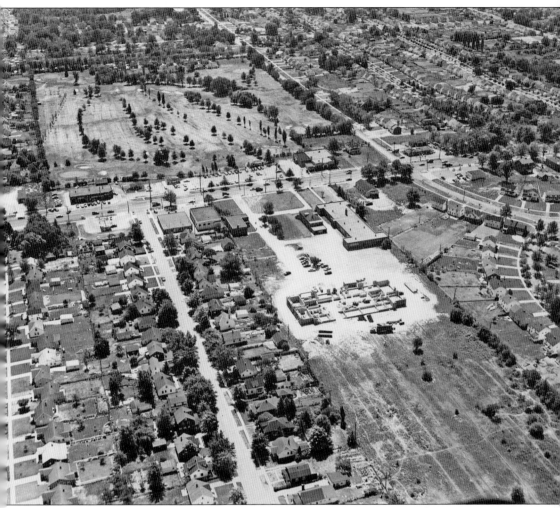

The numbers of schoolchildren continued to grow, so a second school building with 13 classrooms was constructed in 1954. In 1960, a third building was added to connect the other two. The Lyndhurst Golf Course occupied a large section on the southeast corner of Brainard and Mayfield Roads when this photograph was taken on August 13, 1954.

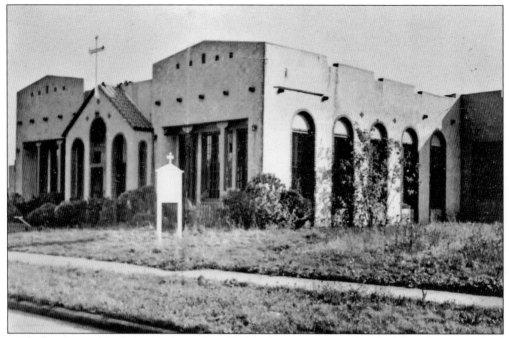

With the classrooms gone, seating in the old church was expanded to 750. The parish expanded so fast that Fr. John Wolf was assigned as assistant pastor.

May 6, 1955, found St. Clare's parish so crowded that a new church was needed. In 1958, ground was broken, and the new church was dedicated in April 1960. At that time, 2,241 families were registered. Father Fitzgerald continued on as pastor and finally retired in 1972. He passed away on June 1, 1983.

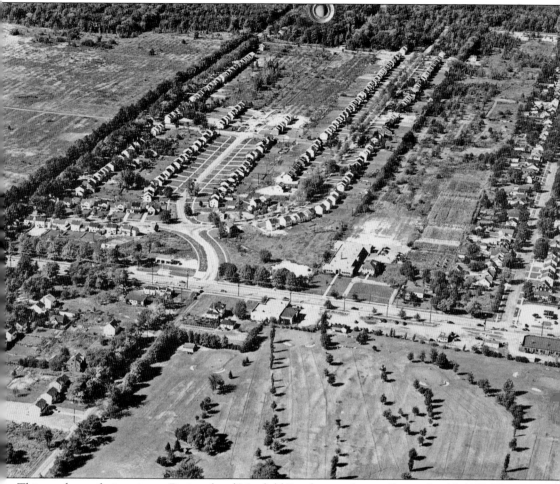

This northwest-facing view at Brainard and Mayfield Roads was taken on September 16, 1951. The Lyndhurst Golf Course and St. Clare's Church share the bottom of the photograph. Harry Brainard's house, later the Well-Kloss Funeral Home, is to their left. The top left corner is where the Cole Airfield, one of Lyndhurst's most colorful and historical sites, was located during the 1920s.

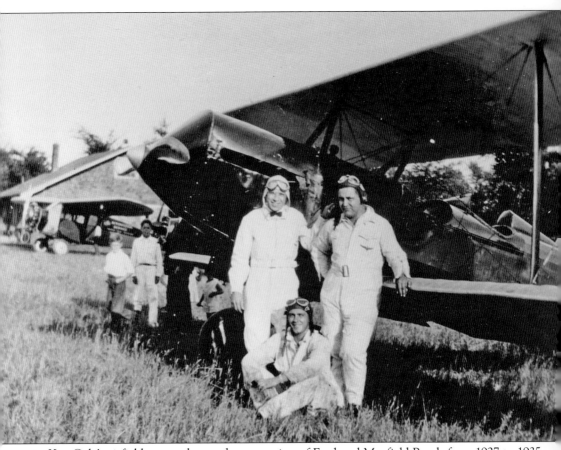

Ken Cole's airfield was at the northwest section of Ford and Mayfield Roads from 1927 to 1935. The hangar for his Mayfair Air Service was where Blanchester Road meets Bolton School's upper ball diamond. A familiar sight in the neighborhood air were the "Three Flying Fools," as they called themselves, Art Siebold (left), Fred Kinstler (seated), and Mike Isabella (right). Their American Eagle OX-5 biplane was used for "bombing missions" in which they dropped flour-sack bombs into tires on the ground. The showering of treats and prizes at Lyndhurst Homedays was an annual event.

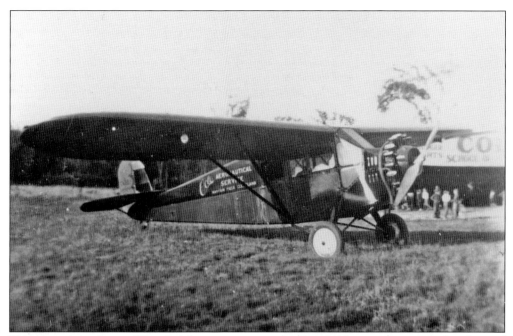

The primary airplane of Ken Cole's air service was this Fairchild monoplane parked in front of the hangar. Aerial photography and both passenger and freight hauling were its main missions.

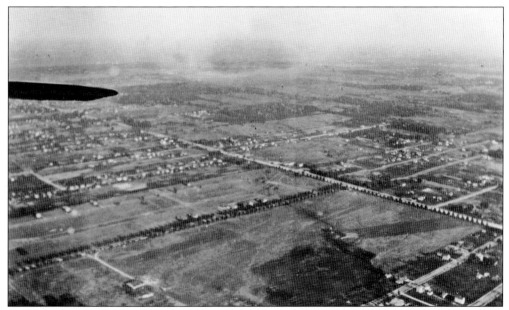

Fred Kinstler took this pilot's view of Ken Cole's airfield in 1932. The hangar is at the lower left. Mayfield Road's intersections with Ford and Brainard Roads are in the center.

Famed aviator Wiley Post, the first person to fly solo around the world, visited Cole Airfield in the early 1930s. He and American humorist Will Rogers lost their lives together in a plane crash on August 15, 1935.

Fred Kinstler seems to understand that the golden era of Cole Airfield is coming to an end. The final straw was when Mike Isabella crashed the "Eagle" into the field east of Ford Road. The crash, the second at Cole Airfield, made Ken Cole rethink his options. He closed the air service and moved to California, taking a job in the growing airplane industry there. The end of the era had arrived.

Eight

THE NEIGHBORHOOD SCHOOLS

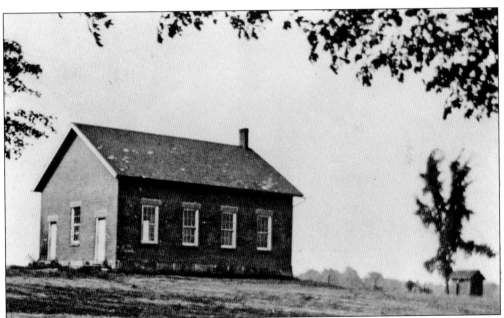

In 1843, Amasa Stebbins gifted a section of the southwest corner of Mayfield and Richmond Roads to the new school board. A small log cabin was constructed and became the first school. The board bought the remainder of the lot in 1861, and in 1866, the educational system passed from its log cabin phase to the "little red school house" era with the construction of the new two-room school. The school was later moved to the back of the lot, where it stands today, after the Lyndhurst Village School was built in 1921.

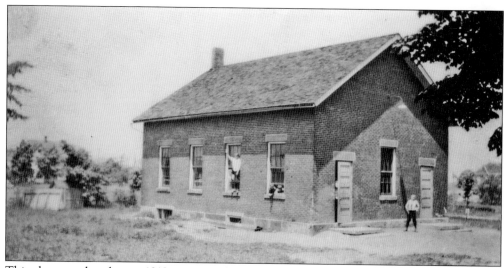

This photograph, taken in 1919, captures the neighborhood kids posing for the photographer in the middle of a Lyndhurst school day.

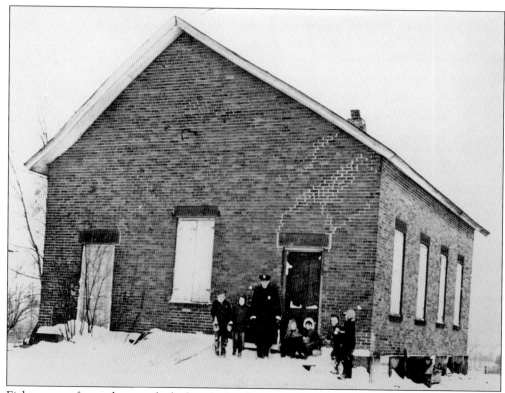

Eighty years of wear show on the little red schoolhouse in this photograph taken on March 4, 1949. The cracked walls and missing light fixture indicated the need for a new school to be built.

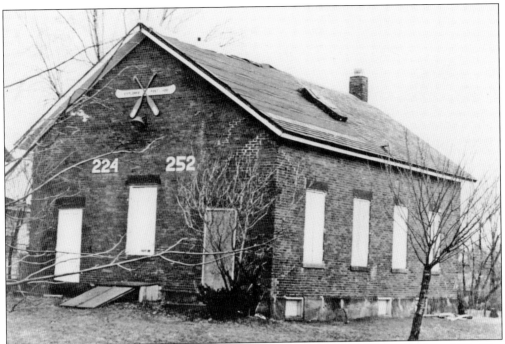

Enrollment decreased rapidly after the new Lyndhurst Village School was built in 1921. The little red schoolhouse was moved to the back of the property, where the Boy Scouts used it as a meeting place. Later it became a maintenance shed for the board of education, and it soon fell into disrepair.

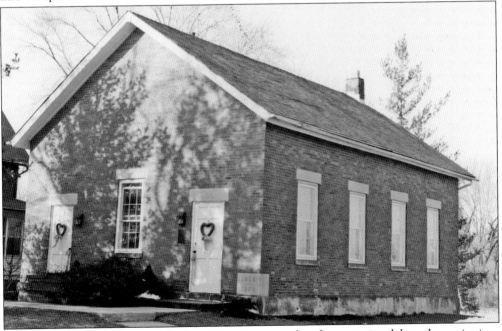

As the 1976 bicentennial approached, a group of citizens enlisted community clubs and organizations to restore the little red schoolhouse. Their goal was achieved, and the dedication on July 4, 1976, included Francis Payne Bolton and Lyndhurst mayor Lester Ehrhardt.

In January 1922, the new Lyndhurst Village School opened with 65 students. The little red schoolhouse then did service as a temporary Lyndhurst Village Hall. "Schoolmarm" Clara Dill recalled that as construction was underway, they would hold their three classes in a barn at the rear of the property. When it got too cold to stay in the barn, classes were held on a rotating three-shift basis next to the potbellied stove in the old brick schoolhouse.

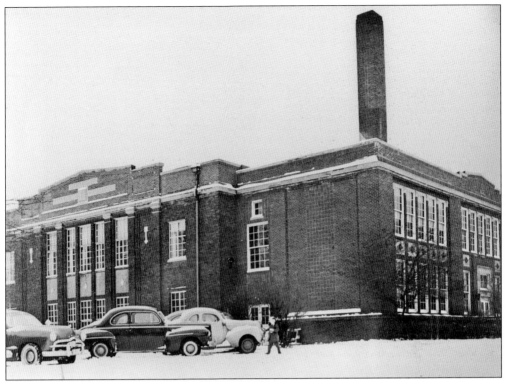

The Lyndhurst Village School is pictured in the 1940s; a young snowball thrower (a popular sport in northeast Ohio) takes aim at the photographer.

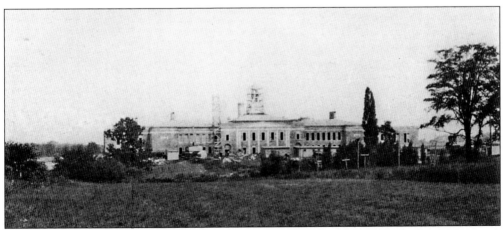

Lyndhurst and South Euclid Villages both faced critical problems. Lyndhurst had no high school, and South Euclid's was overcrowded. School superintendent Otto J. Korb suggested the best solution to this common problem was to join school systems. When the county school board announced this intention in 1924, Lyndhurst objected. It lost in court, and construction of Charles F. Brush High School began shortly thereafter.

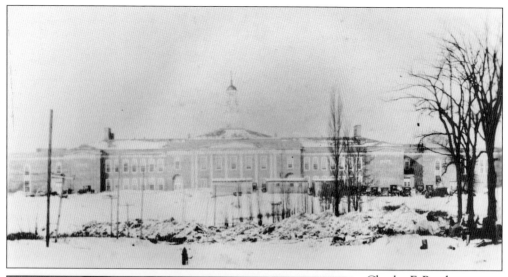

Charles F. Brush High School was built on 18 acres in the geographical center of the Lyndhurst and South Euclid communities. Construction was completed in late 1926, and the first classes were held in January 1927. Charles F. Brush was a Euclid Township native who invented the electric arc light, which would become the streetlights found across America today. The school got its nickname, the "Brush Arcs," from this invention.

Karl Keller, school system social studies teacher from 1920 to 1963, became Brush High School's first principal in 1927. He was the person responsible for naming the school after famed streetlight inventor Charles F. Brush.

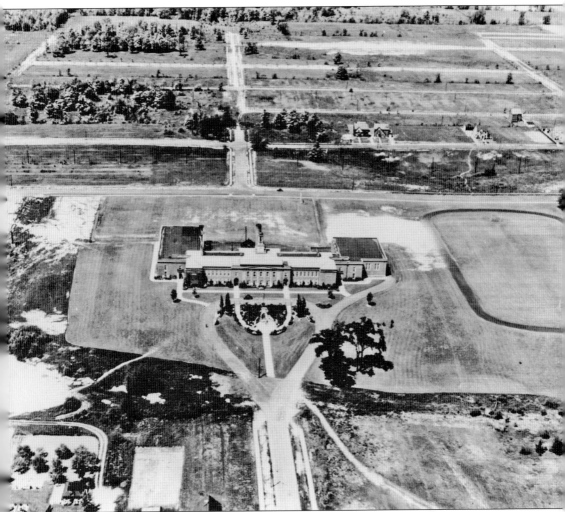

Charles F. Brush High School, photographed from the air on May 23, 1933, shows the streets laid out but house building stopped due to the Great Depression. Memorial Junior High School would be built on the empty field at the top left in 1948. The Korb Athletic Field, on the right, was named in honor of Otto J. Korb, the first South Euclid/Lyndhurst school superintendent.

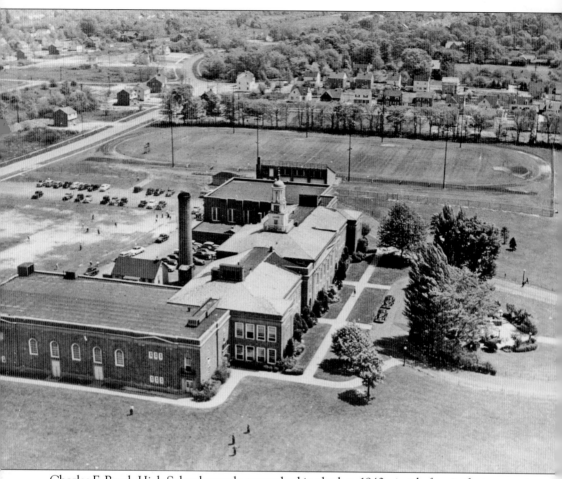

Charles F. Brush High School was photographed in the late 1940s, just before its first expansion. Korb Field had already been upgraded. After World War II, soldiers returned home to resume their normal lives. Many moved up to the suburbs from their original ethnic neighborhoods in Cleveland, Ohio. Homes were being built by the thousands, and schools were needed to educate this rapidly growing population.

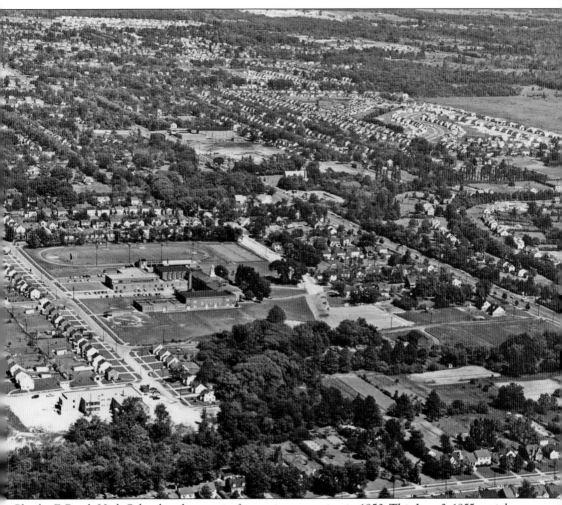

Charles F. Brush High School underwent its first major expansion in 1950. This June 3, 1955, aerial photograph shows the neighborhood surrounding Brush High growing rapidly. To accommodate the added pupils, later additions would include Welser gym, the library/media center, vocational education classrooms, and the instrumental and vocal music wing. Southlyn Elementary School, newly constructed in 1954, is at the bottom left.

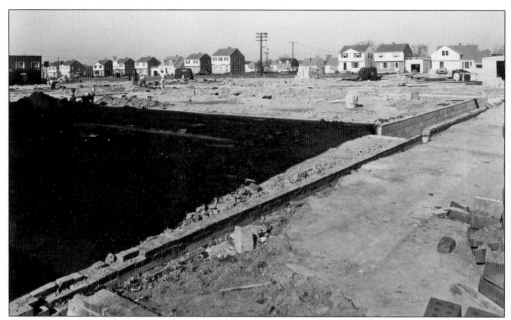

New Charles F. Brush High School classrooms were under construction on November 1, 1950, at the intersection of Roselawn and West Farnhurst Roads.

Southlyn Elementary School had its groundbreaking on July 2, 1954. Homes were filling in fast, and the school expansion was sorely needed. West Farnhurst Road is in the background.

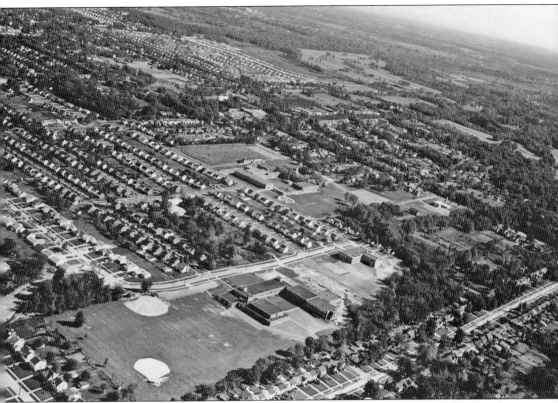

Memorial Junior High School, at the bottom center in this September 29, 1957, photograph, was built in 1949 and named in honor of America's service men and women. Classes of all ages were held there until the elementary schools could be built throughout the neighborhood. It was formally dedicated as a high school in 1952. Southlyn Elementary School is to its right. Charles F. Brush High School, with yet another addition, is seen in the center. Can you spot the other airplane in this photograph? A hint . . . Acacia Country Club is at the top right.

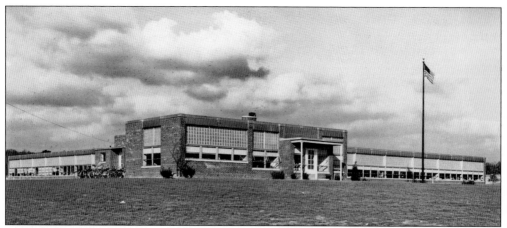

Chester C. Bolton Elementary School, named in honor of the Lyndhurst resident and Ohio congressman, was the first to be built in Lyndhurst since the Lyndhurst Village School in 1922. Bolton started his career as a Lyndhurst Village councilman in 1918. He served in the U.S. Congress until his death in 1939. His wife, Francis Payne Bolton, won a special election to serve out her husband's term.

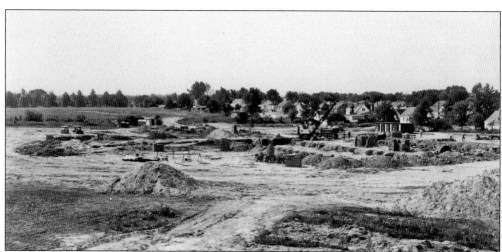

Chester C. Bolton Elementary School is under construction in this September 16, 1949, photograph. Gordon Road runs along the right border, and part of the old Cole Airfield is seen at the top left.

Michael (Mac) Palermo may be the most beloved person in the school system's history. An exceptional athlete while at Brush High School, he grew up to become principal at Memorial Junior High School. This local boy made good is fondly remembered for his smiling face and gentle demeanor.

Mac Palermo's 1952 Memorial Junior High School staff is pictured in the gym during the formal dedication ceremony of that year. Mac is in the center, and to his left is counselor Doris Goven, who had a knack for catching the author with gum in his mouth. She was a great lady but carried those detention slips in her pocket for quick access.

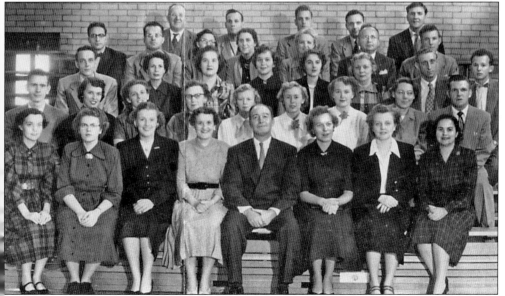

On December 7, 1952, Supt. William Edwards gave the dedication speech that formally opened Memorial Junior High School. Previously holding classes of all ages, it was now the only middle school until Greenview Junior High School was opened in 1961.

In 1991, the Brush Alumni Association broke ground for the fountain restoration project at the high school. From left to right in the first row are Brush High principal Joseph Leonetti, Constance Sabetta and Thomas Murnick of the Brush Alumni Association, and school system superintendent Lawrence Marazza. The Brush Alumni Association also refurbished the clock tower atop Brush High and landscaped the grounds of the school.

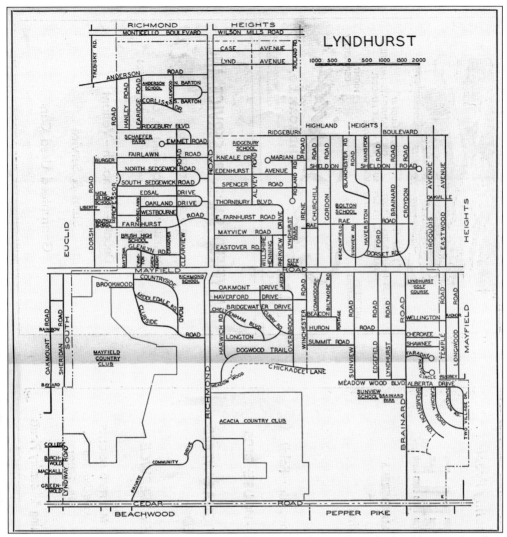

Pictured here is a 1961 map of Lyndhurst. Lyndhurst went from a sleepy little village to a bustling suburb of 17,500 residents in just a few years. Lyndhurst has been both a wonderful place to grow up and a great place to raise kids.

www.arcadiapublishing.com

Discover books about the town where you grew up, the cities where your friends and families live, the town where your parents met, or even that retirement spot you've been dreaming about. Our Web site provides history lovers with exclusive deals, advanced notification about new titles, e-mail alerts of author events, and much more.

MADE IN THE USA

Arcadia Publishing, the leading local history publisher in the United States, is committed to making history accessible and meaningful through publishing books that celebrate and preserve the heritage of America's people and places. Consistent with our mission to preserve history on a local level, this book was printed in South Carolina on American-made paper and manufactured entirely in the United States.

This book carries the accredited Forest Stewardship Council (FSC) label and is printed on 100 percent FSC-certified paper. Products carrying the FSC label are independently certified to assure consumers that they come from forests that are managed to meet the social, economic, and ecological needs of present and future generations.

FSC

Mixed Sources
Product group from well-managed
forests and other controlled sources

Cert no. SW-COC-001530
www.fsc.org
© 1996 Forest Stewardship Council

Find Your Place in History.